BOUDOIR PHOTOGRAPHY

BOUDOIR PHOTOGRAPHY

Mario Venticinque

AMPHOTO

AN IMPRINT OF WATSON-GUPTILL PUBLICATIONS/NEW YORK

First published 1986 in New York by AMPHOTO,
an imprint of Watson-Guptill Publications,
a division of Billboard Publications, Inc.,
1515 Broadway, New York, NY 10036

Library of Congress Cataloging in Publication Data

Venticinque, Mario.
 Boudoir photography.

 Includes index.
 1. Glamour photography. 2. Photography of women.
3. Photography—Portraits. I. Title.
TR678.V46 1986 778.9'24 86-10962
ISBN 0-8174-3561-1
ISBN 0-8174-3562-X (pbk.)

Manufactured in Japan.

1 2 3 4 5 6 7 8 9 / 91 90 89 88 87 86

ACKNOWLEDGEMENTS

A special thank you to my wife, who has believed in me and in our business for the past twelve years, and who has endured my long hours while working on this project.

I greatly appreciate the help given me by the following individuals and companies: Philip Venticinque, who helped me write this book; Rosalie Drnek, another coauthor, who is also my makeup-and-hair artist (her long hours, exceptional talent, and her ability never-to-say never are deeply appreciated—thank you!); Michael West, my assistant; Ken Lerner of Tekno Inc.; Marisa Bulzone of Amphoto, whose enthusiasum played an integral part in the completion of this book; and special thanks to all my clients who graciously consented to appear in this book.

CONTENTS

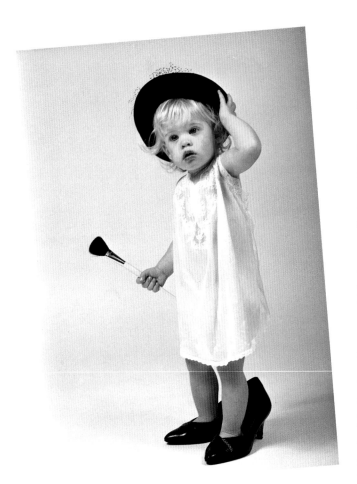

INTRODUCTION

Boudoir photography is relatively new, but it is quickly becoming one of the most popular and most profitable kinds of commercial portraiture. It fills a void in the services available to women at traditional portrait studios. Today's women want to appear as glamorous and elegant—and as sensual—as they feel, and more than ever before, they want to be photographed and remembered that way. Boudoir photography offers special techniques for capturing and enhancing a woman's perception of herself. This is achieved during a unique photographic session that culminates in a lasting portrait of her womanly beauty.

As professional photographers, we can understand the desire to visually document fleeting images and fantasies of the self. Photographs can trigger recollections that would otherwise be lost as life rushes onward. Parents, for instance, attempt to capture childhood by taking snapshots. Envision the whimsical pose of a young girl "dressing up like mommy." This innocent, feminine spontaneity is just what can be rekindled through boudoir photography.

Early in my career, I became aware that many women have a strong desire to look like professional models. After working for numerous studios and commercial photographers, I developed special techniques for a boudoir portrait style in order to evoke the same kind of viewer response generated by advertising photography. This special boudoir style is both marketable and highly recognizable, and in this book I share it with you.

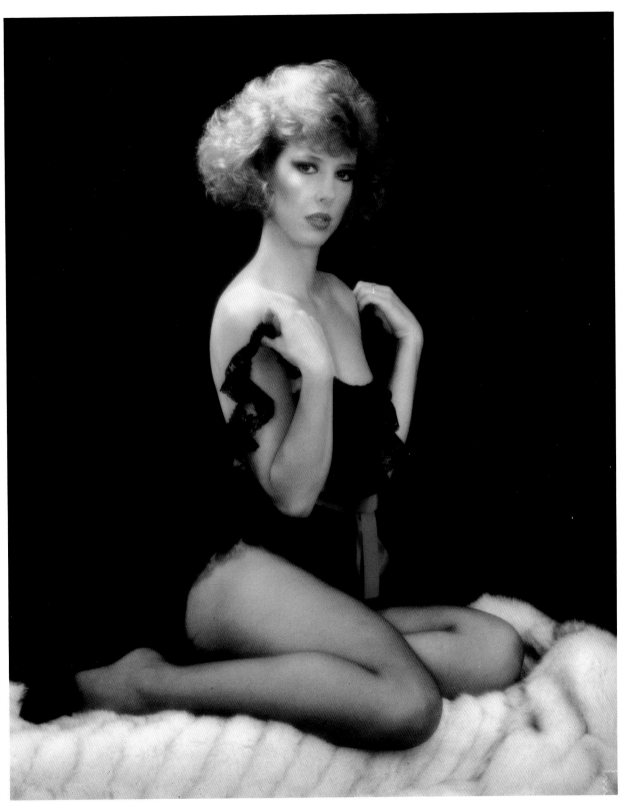

9

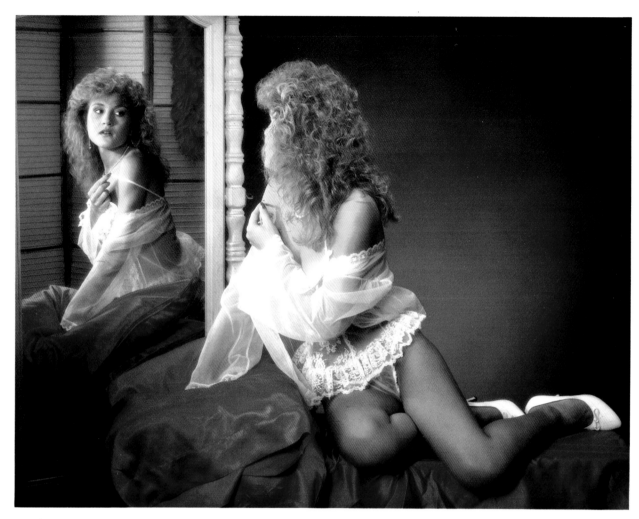

Youth can be enchanting and enchanted with itself. A boudoir portrait is a perfect way of recording this fleeting phase of life for enjoyment in later years.

THE BOUDOIR CLIENT

The boudoir photographer's clients are not professional models. *They come from all walks of life and from no particular age group, income level, or social strata.* They are the women of today, who throughout their development have been innundated with images of glamorous, "cover girl" role models in the media. They also live in a society that cares deeply about the maintenance of personal health and beauty. Sitting for a boudoir portrait gives each client the opportunity to accentuate those qualities and to combine them with a quest for personal freedom and expression that was overlooked in earlier forms of portraiture. Boudoir portraiture allows each client to provide loved ones with a sensual yet discerning glimpse of themselves.

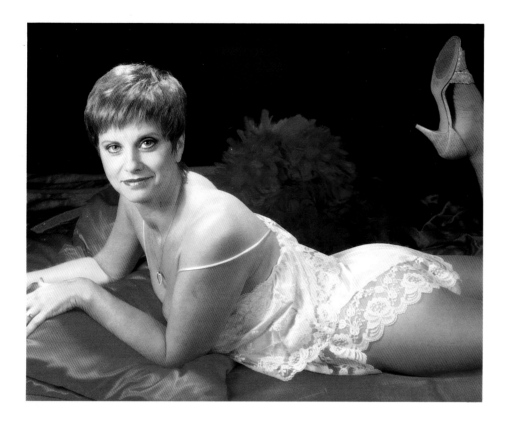

The self-confidence that comes with maturity makes middle age the most sensual time in many women's lives, so it is not surprising that someone in this age group would choose to capture and highlight her "coming of age" with a boudoir portrait.

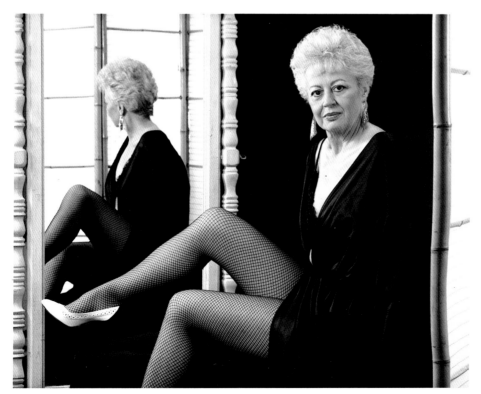

Older boudoir clients usually project a strong sense of individuality, perhaps reflecting a lifetime of health and vitality as well as the self-worth that achievement brings.

The "makeover," or a woman's transformation from her everyday appearance to looking like a glamorous cover girl, is one of boudoir photography's biggest selling points. Boudoir studios employ makeup-and-hair artists in order to achieve the kind of stunning before-and-after results that you see in these two photographs.

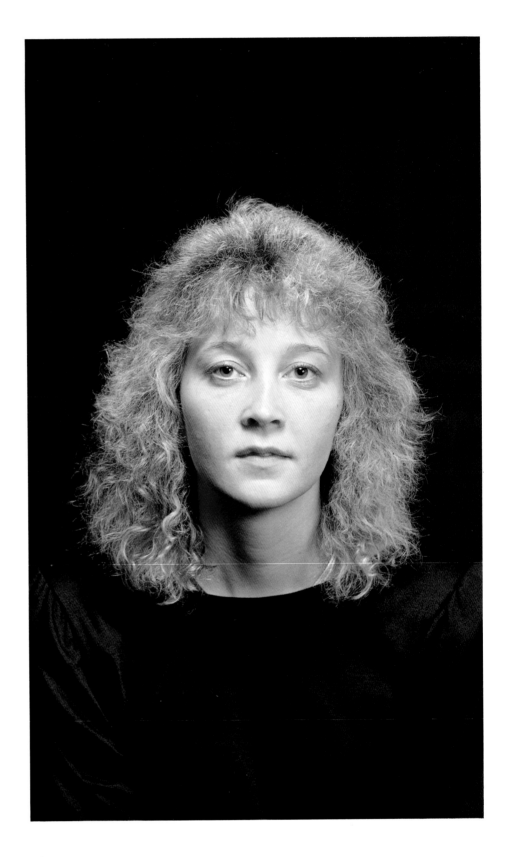

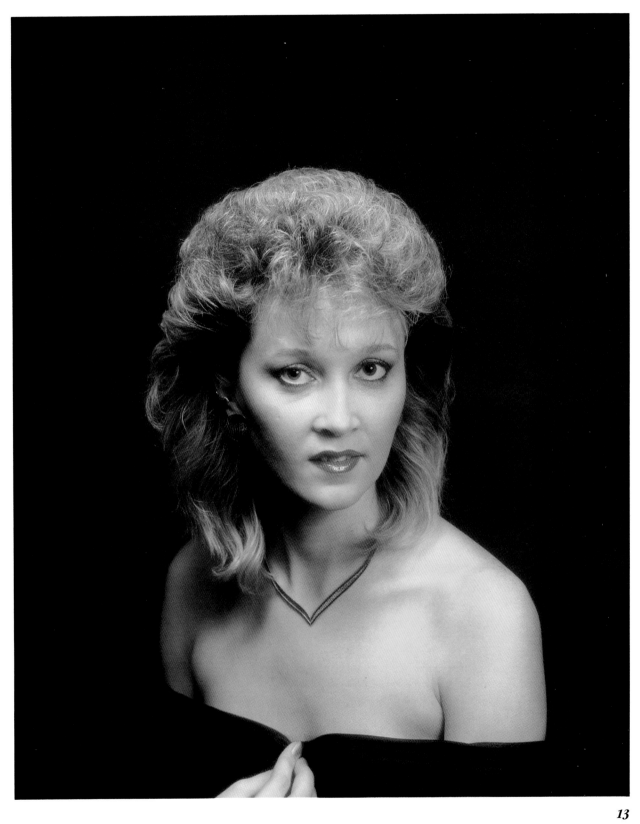

13

During a boudoir session, each client hopes to undergo a complete transformation. This transformation is accomplished through the concerted team efforts of the photographer, the client, and most importantly the professional makeup-and-hair stylist, who is an integral part of boudoir photography. When a client receives the right hairstyling and makeup before her photo session, her transition into the glamorous "cover girl" of her fantasies is easily accomplished. You will find that this process not only provides an instant ego boost for the client but also gives her a satisfied feeling of immediate, tangible results prior to any shooting. It is this additional attention that further differentiates boudoir photography from the portrait photography with which we are so accustomed.

THE BOUDOIR PHOTOGRAPHER

Because my goal as a boudoir photographer is to illuminate the essence of each client's persona, I feel that I am afforded an exciting opportunity to utilize my technical ability in a creative way—capturing the alluring rapture of the human form.

Clearly, boudoir photography is a delicate segment of the photography business, so the photographer must at all times maintain a professional posture in a studio environment emphasizing elegance, quality, and glamour. Establishing credibility and confidence is a paramount necessity in the operation of a successful boudoir studio.

Those of you who make the transition to boudoir photography must assume responsibility for maintaining the discreet balance required to photograph clients in fantasy-like surroundings. You can learn how to present your clients in a sensual way by utilizing the various techniques discussed in this book. Our job is to accentuate each client's best attributes in an interesting final composition *that will be acceptable and saleable to the client.* Never forget that this sensual portrayal is for the client—we must not confuse our efforts with tawdry, lewd pornography!

Your ultimate goal must be to establish an ongoing profitable studio. As in any business, you must understand the specific need for a type of product or service. Moreover, the decision for you to enter into this unusual kind of photography should be preceded by a thorough self-examination. This will assure you that you have certain personality traits that are just as vital to success as your technical skills.

As a boudoir photographer, you must be able to capture the intrinsic personal pride and self-esteem that each client possesses and permanently transfer it to a photograph. Just as your client must be made to feel comfortable, you too must be comfortable with this type of photography. Photographing the human form is quite a departure from photographing still life, landscapes, events, and animals in their natural habitats. Are you capable of generating a creative dialogue with each of your clients? Your ability to act as the creative catalyst for each session is extremely important.

Creativity, originality, style and the continual need to exercise your imagination—these are the qualities you will need to be a successful boudoir photographer. Your clients will depend on your ability to inspire them to emphasize their best features and attributes. Producing each boudoir setting will be left to your imagination. Do you see yourself as the type of individual who can work in a semi-structured, relaxed, studio environment? Can you function in an atmosphere where business constraints are put on you as a photographer? Are you confident and quick to conjure up ideas for completing each session efficiently and profitably? And, of course, the ability to interact and communicate with nonprofessionals, who need special understanding and reassurance, is essential.

In keeping with your goals, I must stress that a prerequisite for your professional transition into the boudoir format necessitates that you invest in a permanent studio environment. I strongly dissuade anyone from attempting boudoir photography in anything less than formal surroundings. The formal setting is a very important step toward insuring that your credibility in doing this kind of photography remains intact. As a studio owner, you must present your business to the community in an open, candid manner, making every effort to enlighten people so that they can fully understand boudoir photography. The establishment of your boudoir studio will allow you to realize your own career fantasies, but be prepared to understand that nurturing your goals may test your ability to withstand negative or adverse opinions.

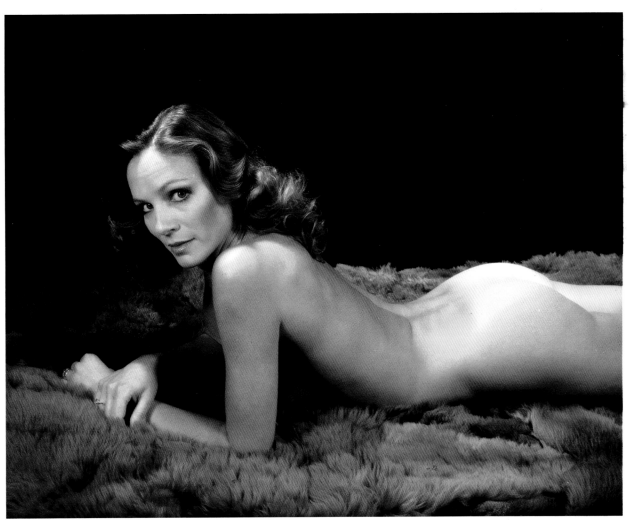

Winning your client's trust and goodwill is the first step toward uncovering and documenting her innermost self. Your personal credibility must always be unimpeachable if you expect to include nude photography in your studio's repertoire.

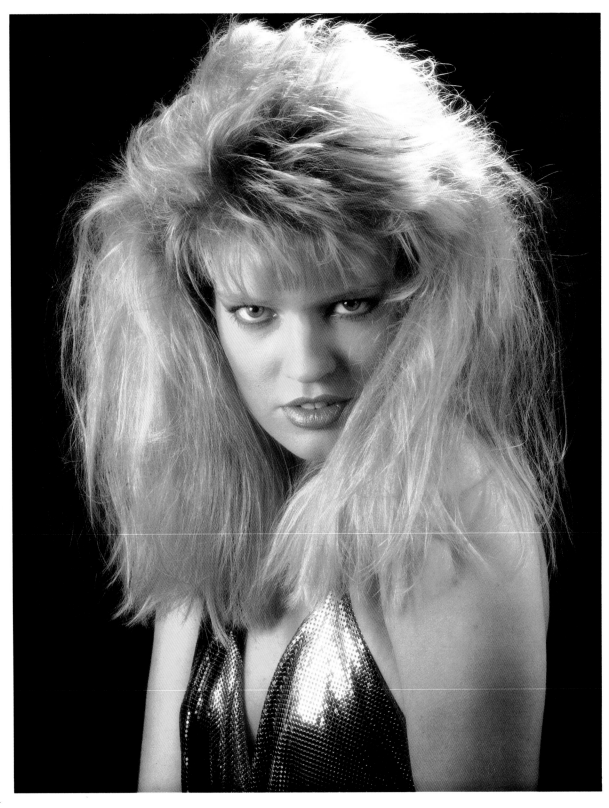

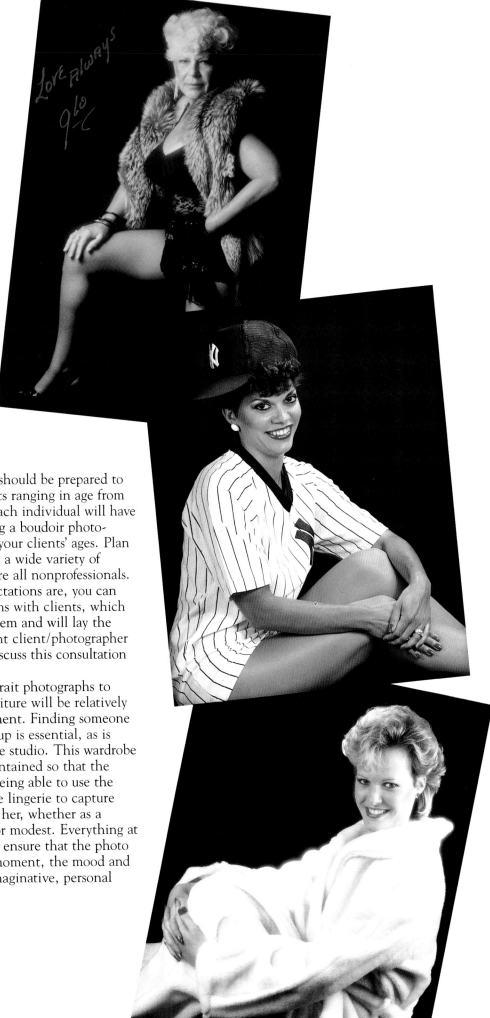

The tigress, the vamp, the tomboy, and the modest girl all are examples of the various fantasies that women have about themselves and want to portray in boudoir photographs.

As a people person, you should be prepared to work (as I have) with clients ranging in age from nineteen to seventy-one. Each individual will have personal reasons for wanting a boudoir photograph, reasons as varied as your clients' ages. Plan to build your clientele from a wide variety of individuals who naturally are all nonprofessionals.

To learn what their expectations are, you can hold individual consultations with clients, which will instill confidence in them and will lay the foundations of the important client/photographer relationship. Later, I will discuss this consultation in detail.

The transition from portrait photographs to boudoir personalized portraiture will be relatively easy with respect to equipment. Finding someone to do hairstyling and makeup is essential, as is keeping some lingerie at the studio. This wardrobe should be selected and maintained so that the photographer can rely on being able to use the visual impact of provocative lingerie to capture each client as he envisions her, whether as a tigress, a vamp, as playful or modest. Everything at the studio must be ready to ensure that the photo session pulls together the moment, the mood and the magic into a lasting, imaginative, personal portrait.

DEVELOPING YOUR OWN BOUDOIR STYLE

All photographers know the exhilarating feeling of squeezing the shutter and knowing that an image has been caught, an image powerful enough to be provocative without any caption or further comment. This feeling is the starting place for originality—in itself, this feeling motivates us to find new and original ways to accomplish our art. When you can achieve a strong, involuntary viewer response to your photographs, you are ready to develop your own photographic signature. But first you must acquire all the technical skills necessary for translating what your imagination wants to communicate through your camera's lens and onto photographic paper.

Ultimately, you are striving to allow your boudoir clients to express their inner selves through your technical expertise and imaginative ingenuity. Boudoir photography is not unlike silent film. Reflect, for instance, about that old medium. The entire emotional story line was communicated to the audience through action, through gestures and through exaggerated facial and eye expressions.

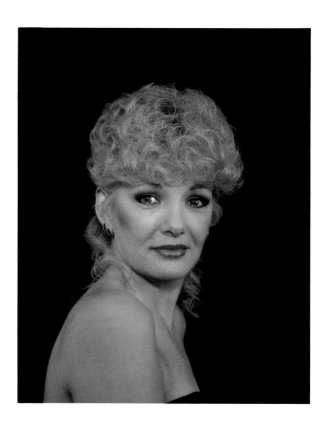

Modeling can be a lot of fun for the boudoir client and the photographer, who together are trying to create a series of photographs, such as the one shown here, that tell a story expressing different aspects of the client's personality.

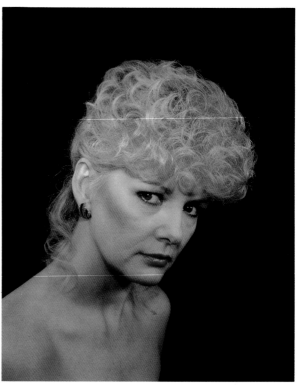

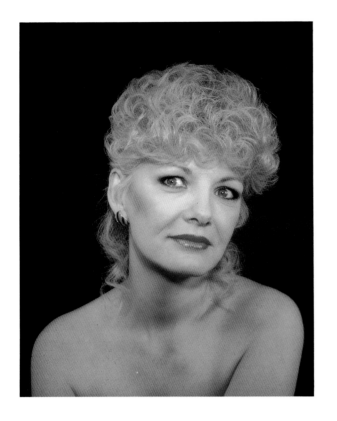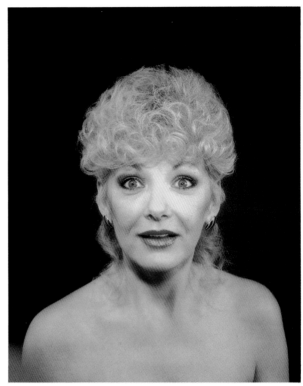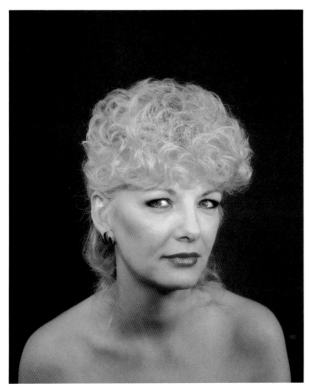

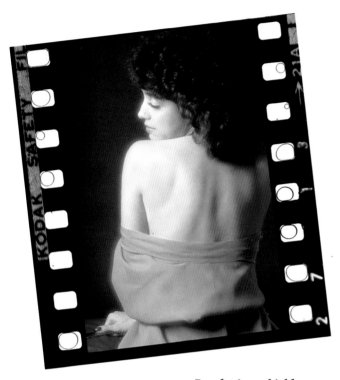

Developing a highly recognizable style is essential for showcasing the special merits of your particular boudoir studio. My own "signature" style is readily apparent in these photographs (above, and on opposite page) that demonstrate my preference for dark backgrounds, rich colors, an off-the-shoulder pose, and selective lighting.

Boudoir photography lends itself to your drive for originality, your personal style and creative impulse. There is no reason to be caught up in yesterday's trends or portrait styles. Remember that the present is extremely important in developing and marketing original boudoir photographs—we are offering a unique package to today's clientele, not yesterday's. Originality, creativity, and style are the ingredients that, when mixed with your technical ability and the subject's personal chemistry, will make each session a successful and profitable one.

Strive to be contemporary in your endeavors, and unleash your creativity by trying new and different approaches to the photographic craft. For instance, make an attempt to photograph a subject without the traditional posing table, stools, or any of the familiar "portrait" paraphernalia. Creativity should not be a function of using props. I'm not condemning props; I'm merely saying that once you have learned not to rely on them they can be used properly to enhance your work.

This book was written for photographers whose level of competency enables them to venture into a realm of creativity where specific photographic "musts" can be abandoned. I recommend setting aside some time for experimentation. Break some rules so as to develop your style. Try to anticipate the result of your actions before you see the Polaroid—and always make it a point to establish a way to repeat successful techniques. You will not make a profit if you can't re-create your successful attempts. Don't rely on using a string to measure the distance between your light source and your subject for metering—cut it! When you find an accident that works, refine it so you can add it to your portfolio or more importantly, display it on your studio wall. Eventually, following this process will lead you to germinate your own, specific style, one that is highly recognizable in public without your name at the bottom of your work.

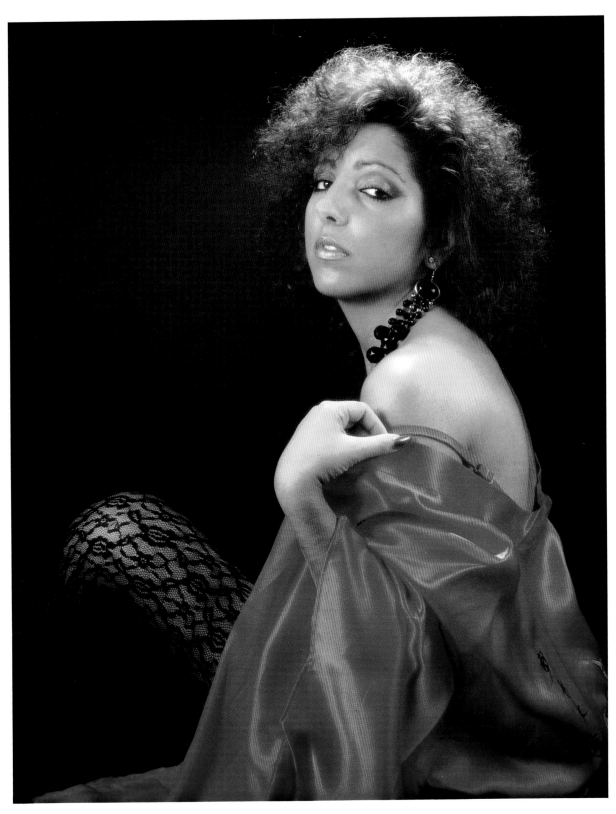

SELECTING THE EQUIPMENT

Establishing what you need and then selecting the right equipment and film is a critical process, which, when opening a studio, merits careful planning and consideration of your goals. For boudoir portraiture, the initial expenditure on the necessary equipment is minimal if compared with the outlay for a full-service commercial studio. Your first concern is that the equipment be functional and capable of producing images of the quality needed for boudoir work.

CAMERAS

When I opened my studio, one of my first cameras was a Yashica D $2\frac{1}{4} \times 2\frac{1}{4}$ that cost approximately $130, and a Nikon 35mm system. I used the Yashica as my studio camera, and I used the Nikon for public relations work, composites, and weddings. A purchase of a $5000 Hasselblad system would have been financially impossible for me at the time and unnecessary as well. Boudoir work requires diffusing the lens to prevent skin pores from being too sharp and unflattering to the client's appearence in the finished portrait. The Yashica's lens quality required no further diffusion. Enlarging negatives made with a Yashica lens to $16'' \times 20''$ resulted in a final print that looked as if it had been taken with a diffused Hasselblad lens or Mamiya lens. Once my boudoir business became profitable I was then able substantially to upgrade my equipment.

LIGHTING EQUIPMENT

It has always been my opinion that lighting equipment should have top priority. As a photographer, you know what it actually takes to record an image on film—lights! Too many photographers overemphasize cameras in portrait work. Nonprofessionals constantly ask me what cameras I use, but never do they ask about my lighting equipment. Remember, the formula is lights, camera, action, not camera, lights, action!

Lighting equipment manufactured by Balcar includes an array of products that are especially useful in boudoir photography. Balcar equipment is lightweight and affords the specific kinds of control necessary for photographing people. Balcar grid-spots, for instance, offer a selective form of lighting that umbrellas can't provide, since an umbrella lights up the entire figure. When photographing women, grid-spots are much more effective for emphasizing some areas and hiding others.

I'm not suggesting that you throw away your umbrellas; I'm just recommending that you remember to keep your options open when purchasing lighting equipment. Buy only what you can afford and will use regularly, and buy only equipment that you find comfortable and that allows you to function efficiently. To start with, purchase at least a 1200 watt sec. power pack with a minimum of four heads, preferably fan cooled.

Your ability to be creative sometimes depends on the versatility of the equipment you select. For

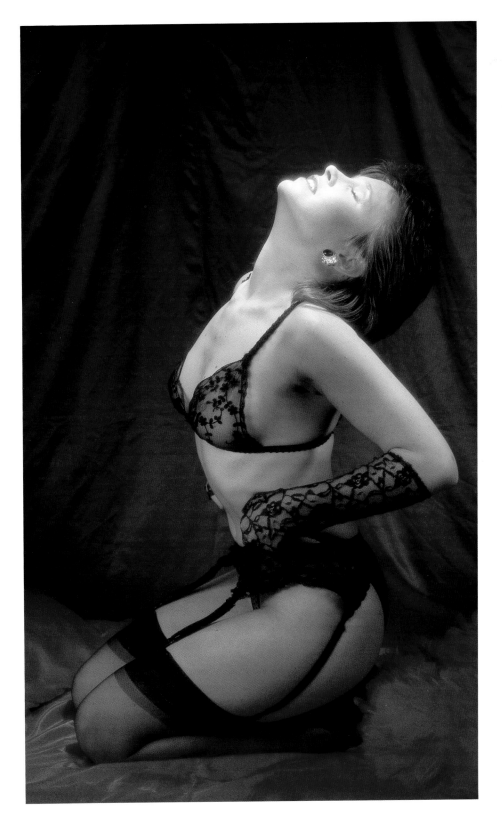

Using grid-spots rather than bank lights allows the photographer to select and highlight certain areas of the client's figure, which is well demonstrated in this dramatic photograph. Soft, diffused light from above plays up the client's lovely head and torso, but permits her legs and thighs to sink into the background.

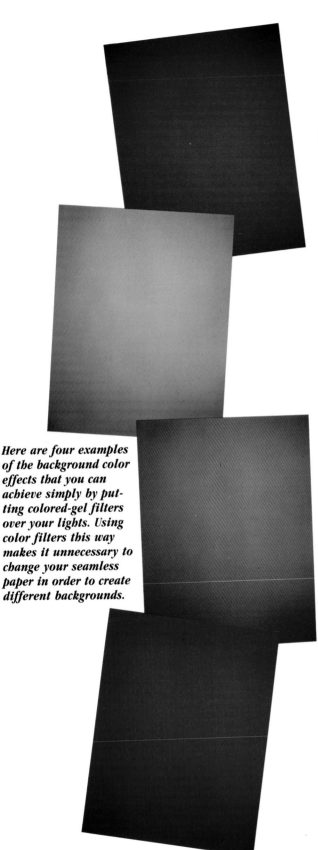

Here are four examples of the background color effects that you can achieve simply by putting colored-gel filters over your lights. Using color filters this way makes it unnecessary to change your seamless paper in order to create different backgrounds.

example, portrait photographers around the country may be using the same, basic two-light setup resulting in all portraits being lit essentially the same way. It is really important not to limit yourself like this. Don't allow yourself to be stifled because you lack flexible equipment. When opening your studio, the purchase of good, functional lighting equipment is a must in order for you to light your clients effectively.

I use Balcar flash systems that have power packs available in three different ranges of power output: 1200, 2400 and 5000 watt secs. Otherwise, they share the same characteristics. Each model lamp used can be set in proportion to the power of the flashtubes. A Balcar flash unit is divided into three individual flashes (A, B, and C) which can be grouped together in different ways. They can be used together for equal output from each light-head; ¾ of the power can be split between A and B with ¼ of the power going to C; or ½ of the power can go to A, ¼ to B, and ¼ to C. The split flashes help you control the main and fill lights directly from the power pack without having to move light-heads around to get your desired *f*-stop. Balcar light-heads used in conjunction with their power packs make a perfect match made in heaven!

I suggest that you buy a Balcar set of seven color filters that are heat resistent mylar and that clip onto grid-spots, which will allow you to create colored backgrounds without changing your seamless paper. Used together with grids, filters help you create special effects on backgrounds, hair, and skin. When using colored-gel filters to light a black background, this light must always be stronger than the main light on your subject, in order to achieve the density of background color that you want.

Since the business of boudoir is making women look their best, certain lighting accessories and techniques are especially useful, one of the best being the use of grid-spots. These are used for making very sharp edges on the subject or making soft, diffused edges with a gradual falloff of light. Grids are also ideal for directing light onto your client's best feature. Direction, control, and convenience mean a great deal to the working photographer. For those reasons, I now work exclusively with Balcar's new Prisma light-box and grids.

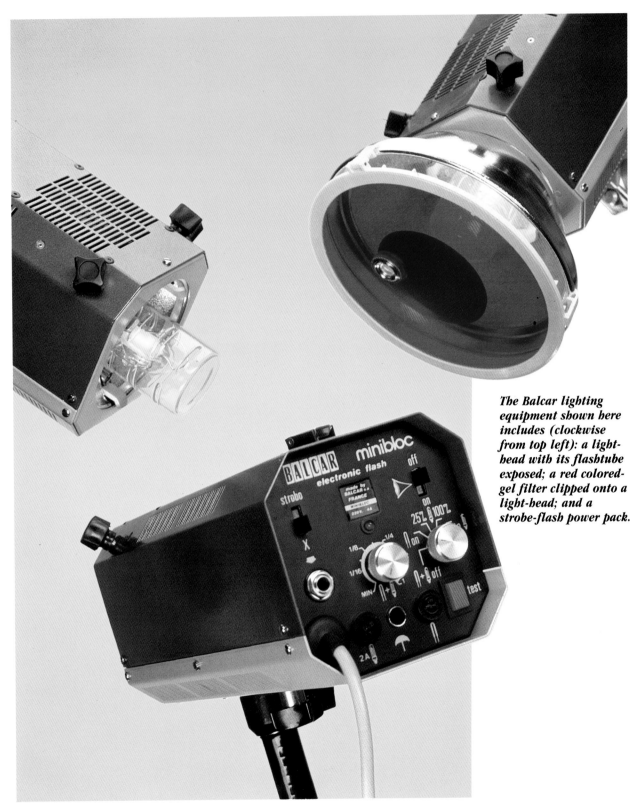

The Balcar lighting equipment shown here includes (clockwise from top left): a light-head with its flashtube exposed; a red colored-gel filter clipped onto a light-head; and a strobe-flash power pack.

25

These multifaceted light-boxes are constructed of two different kinds of panels—diffusing panels and reflecting panels, as seen at the left—and are ideal for boudoir work. Diffusing panels are white and may be bent. They reflect 60 percent of the light and transmit 40 percent but used in a light-box more than 70 percent of the light is transmitted because of multiple internal reflection inside the box. Reflecting panels reflect light directionally in a diffused way, like white panels do, but with the light-output efficiency of metal sheets. Using a Prisma light-box combined with a colorless pyrex shell to correct the color temperature of your flashtube will give you a perfectly balanced light for daylight films, resulting in beautiful, warm skin tones.

There are two major reasons for using Prisma light-boxes instead of umbrellas. The falloff of light is great with umbrellas, but the three-dimensional shape of Prisma light-boxes eliminates that problem: one facet lights the subject, another the background, and a third lights a reflecting panel. Secondly, umbrellas used close to the subject always get in the way of the lens because of their shape and cumbersome bulk, which is not a problem with the Prisma light-box.

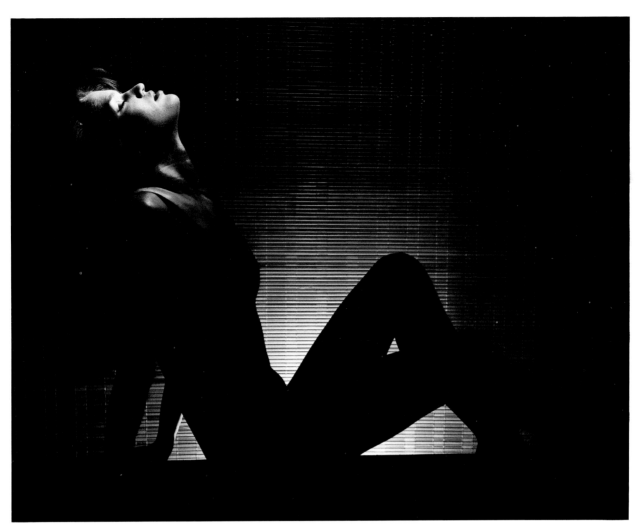

Grid-spots are ideal for contrasting one high-lighted area of the fig-ure with another area that leaps out in stark silhouette, as shown in the above photograph. The diagram to the right illustrates the place-ment of the grid-spot above the client's head and of the light-head behind and beneath the surface supporting her.

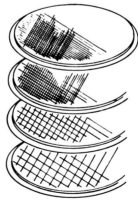

This drawing of grid-spot filters gives you an idea of the various de-grees of diffusion avail-able.

27

QUALITY CONTROLS

To build a good reputation in this business and be respected by your peers, you must maintain consistency and quality in your work. Do not let mediocre prints leave your studio. You must be secure in your own mind that you gave each assignment your all, because cutting corners will catch up with you. Other photographers will also view your work, and any negative technical comments that they make about it will eventually hurt your business. Keep in mind that I said *technical* comments, not *aesthetic.* Color consistency in your prints is a must when photographing women. Hair color, skin tones, and costume colors must be well rendered for you to demand prices that are considerably higher than what department stores charge for prints.

Test everything! Find which films work best for you under specific situations. Kodak's first rating of its films is just a guideline, not the final measure used by professionals. Again, run tests to see which ratings yield the best results for your negatives. I ran tests on Kodak's Vericolor III Professional film and concluded that an ISO of 125 gave me excellent skin-tone reproduction. To evaluate exposure on color negative film, hold it over your light-box and view it through a green filter (Kodak Wratten Filter #61). This will make your color negative appear black and white, which will help you determine whether there is enough detail in your shadow areas.

Vericolor III Professional film affords some distinct advantages. Since the film is designed with low contrast, it enables much softer high-lights, and it allows a bit more open-shadow area. Also, it provides good detail in shadows, since dark clothing and black skin tones would other-wise block up in printing and appear to be one solid mass.

Most clients prefer color prints but sometimes when they enter your studio and see samples of black-and-white work, they decide they would like you to shoot them in black and white, or do a roll of each. Plus X Pan black-and-white film is optimal for extremely fine grain and sharpness, while it still maintains excellent definition and wonderful tonal qualities. Whatever black-and-white or color film you choose to use, understand-

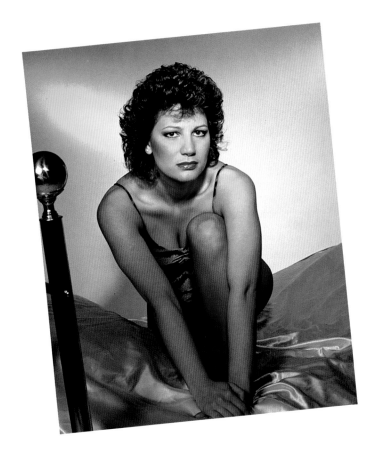

ing its characteristics will enable you to underex-pose and overexpose it with predictable results. Graininess is much more prevalent when overex-posing or underdeveloping black-and-white nega-tives, and conversely, when underexposing or overdeveloping color negative film.

If this occurs, you can somewhat diminish graininess when you print the negative by soften-ing the focus in the enlarged image, or by printing through a piece of mesh screen. Try to make your prints look as attractive and as lifelike as you can. Your business will grow rapidly when people learn that they can always count on excellent quality from you, quality that they will gladly pay for.

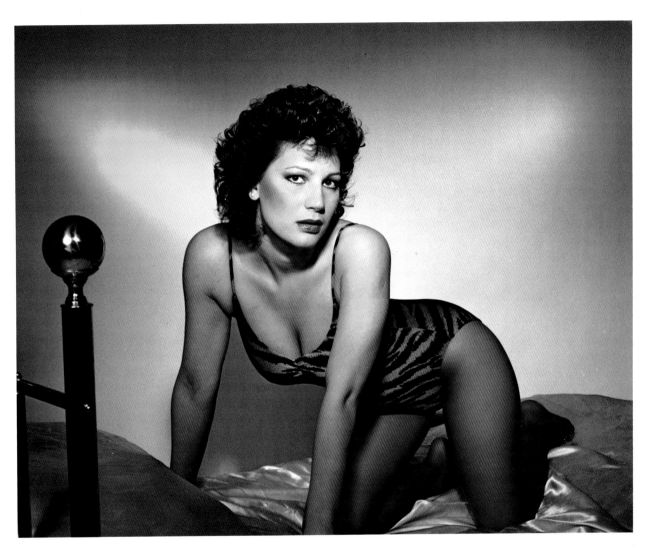

These photographs show an excellent range of skin tones. I balanced the purple and gold background colors to complement her yellow-and-black leotard by directing lights with colored-gel filters onto a gray, seamless paper sweep.

29

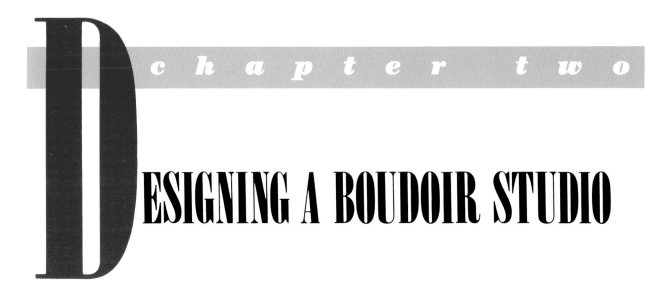

DESIGNING A BOUDOIR STUDIO

The boudoir photography studio does not require any grandiose decorating scheme. I do, however, suggest that your basic décor stress the contemporary nature of boudoir photography, not the naughtiness of a Gay Nineties bordello. As I mentioned earlier, creating a formal yet relaxed studio environment is essential for guaranteeing your credibility with your community.

Lofts are the first kind of workspace that currently comes to mind of many aspiring photographers; however, for boudoir work the storefront location is more advisable, primarily because the storefront makes clients feel more secure and comfortable. I opted for a location with a large, double-glass front, so that I can utilize natural light if the need arises. And, as described before, storefront windows provide excellent space for showcasing your work and displaying accessories (such as picture frames) that provide extra income. How you choose to do your window signs depends solely on your budget and your personal preference. Lettering can be permanently painted onto windows; you could use a neon sign or use Plexiglas. These options can all be augmented with various "special offer" signs that are removable and interchangeable.

WORKSPACE CRITERIA

Your main consideration in planning the studio's layout is that it be functional, providing adequate space for the shootings, dressing rooms, a recep-

tion area and a semiprivate setting for initial sales presentations and client consultations. The physical dimensions of a prospective site will determine whether or not it is suitable for your boudoir studio. The approximate size requirements for a good size must include at least 30′ × 40′ with a minimum of a 10′-high ceiling for your photographic work. In addition, remember to allot approximately 5′ × 6′ for a dressing room. The reception area need only be 8′ × 10′, and should have quick access to either the studio or the consultation area. The latter need be no more than 10′ × 12′. Interior walls around the reception and consultation areas can also be used to display your work. Be sure to provide some space for storage and filing, which can be done during the natural time lag between shooting, processing and delivering the final product to your clients.

How your studio looks during daily working hours is naturally important. Cleanliness and a tidy, orderly appearance aid in projecting a well-run, business-like image. Choosing colors that are light and contemporary will help complement the ambience that you want to create. Studio furnishings, such as seating in the consultation area, counters, and your photographic workstation, can be very easily constructed by you or be purchased from local sources. Make sure to include some counter space in the reception area for scheduling and phone calls. Once the basic requirements of space and function have been satisfied, you are ready to begin creating an atmosphere.

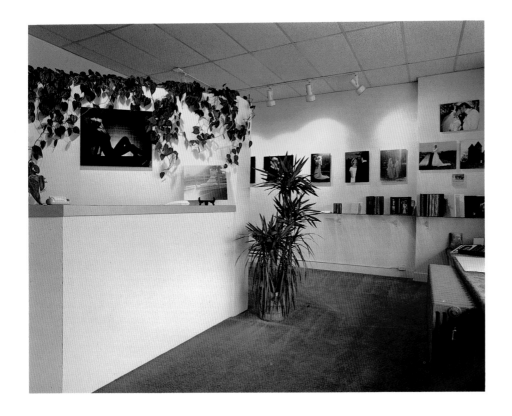

The reception area in my studio leaves an agreeable first impression, as you can see in this photograph. My receptionist greets clients from behind the counter to the left, and natural light streams in from the storefront window (not seen) to the right. Plants and carpeting help make the environment feel comfortable and safe, and my photography hanging on the walls reaffirms the high quality of my work.

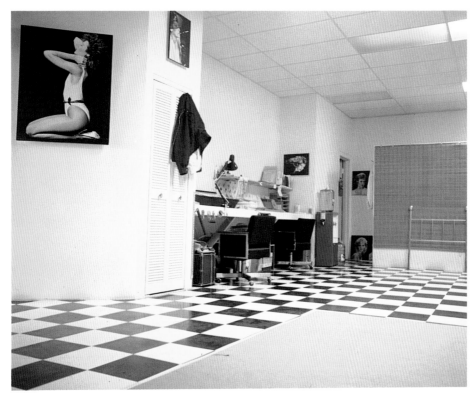

This is where my photo sessions are held. In the foreground you can see a corner of gray seamless paper, and in the background, a brass bed post leans against a bamboo screen. These are all common elements in my sets. A work counter runs along the left wall.

31

Tips for Glamorizing Your Studio

● *Plants (live or silk) provide colorful contrast and create a well-intentioned, peaceful atmosphere.*

● *Contemporary music is a must for soothing nerves—but don't use anything canned or piped-in, or anything that sounds like elevator music. If a central system is available, use it; otherwise, a simple cassette system with a few, strategically placed speakers will do nicely. Purchase a library of your own tapes and use them to help set a busy, dramatic pace in your studio.*

● *Dress in keeping with a relaxed but active atmosphere. Suits and ties are too formal—you need to favor a casual appearance, not a staunch one.*

● *Provide other subtle, classicly feminine accents throughout the studio, for example: cut flowers, special toiletries, perfumes, deodorant, and powders.*

Here is another view of the reception counter which also acts as a room divider for the consultation area to the right. The pink door to the left opens into the working studio.

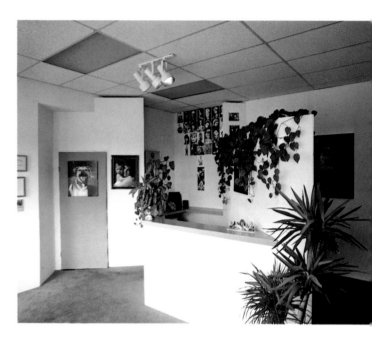

Shopping malls are ideal locations for boudoir photography studios because malls are well trafficked (thus giving businesses good exposure) and impart an attitude of community acceptance toward the businesses they promote. The long, narrow floor plan shown here was especially adapted for rental space at a mall.

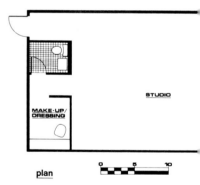

plan

I chose a storefront for my studio location, which has suited my boudoir-photography business needs perfectly. This floor plan of my off-street location is a good example of a well-planned studio, from its window displays to the bathroom off of the dressing room.

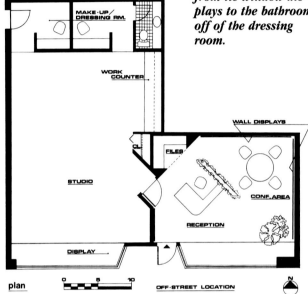

MAKE-UP/DRESSING RM.

WORK COUNTER

WALL DISPLAYS

CL.

FILES

STUDIO

CONF. AREA

RECEPTION

DISPLAY

plan

0 5 10

OFF-STREET LOCATION

N

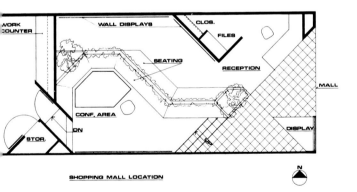

WORK COUNTER

WALL DISPLAYS

CLOS.

FILES

SEATING

RECEPTION

MALL

CONF. AREA

DN

STOR.

DISPLAY

SHOPPING MALL LOCATION

N

THE PERSONAL TOUCH

Boudoir photography exudes glamour, so the atmosphere of your studio must really breathe with the luxurious feeling of a "glamorous" environment. In the reception area, use track lighting or mini-spots to highlight your wall displays. (Window displays can also use spot or track lighting to good advantage.) Deep-pile carpeting in the reception and consultation area will also create a plusher appearance. Soft music, flowers and simple, tasteful sculpture can help to underscore the elegance of the boudoir experience.

The dressing and make-up room requires some additional attention beyond the importance of placing it in an area of the studio that is not heavily trafficked to insure privacy. I have found that using mirrors edged with bars of lights, the kind used by movie stars to put on their makeup, works well along with shelving to hold beauty supplies. Wall hooks and hanger racks will allow your client to change clothes comfortably, and carpeting will protect her bare feet from the cold floor. Although privacy is necessary, I've discovered that the client makes an easier transition into the studio if she is not allowed to barricade herself behind a door in the dressing room, so I suggest that you use curtains, beading or louvered doors. The client should be allowed to exit directly into the studio area, where she will encounter studio lighting, not bright, unflattering fluorescent light.

Just as your personal signature is present in your photography, so too should your studio surroundings reflect your personal touch.

Your conduct and that of your employees, along with your ability to create a businesslike climate that is relaxed and hospitable, will provide the sparkle that can't be left for walls, layout, paint, and displays to provide.

How you name your studio can give you an edge in creating that ambience. There are some pros and cons about using a generic sort of name versus personalizing your studio with your own name. I chose to use my own name because I felt that personalization was an important aspect of my boudoir portraits. If you opt for a generic-sounding name, it may be harder for you to build the confidence of your clientele since there will be less of an "exclusivity" connoted.

33

ADVERTISING

Boudoir photography's very existence is a by-product of the advertising industry. That is to say, it is professional advertisements themselves that have enticed and motivated our clients to want to look as sexy as professional models and be photographed in the same glamorous settings.

Advertising is the keystone in the promotion of any business and I feel that it is especially critical in promoting boudoir photography. What people perceive through your advertising efforts can indeed affect community response to your work. Advertising will put your studio into a different category from those boudoir studios that have to rely on referrals and walk-in trade.

At first, you will want to devote some energy to introducing and educating the public as to what boudoir photography is. And you'll want to be sure to scale your advertising efforts so as not to exceed your capacity for new business. You don't want to place major media ads evoking so much response that you are unable to handle the sudden influx of clients.

There are no cut-and-dry formulas for determining how much to spend on your advertising campaign. After you familiarize yourself with the costs of using various types of media you will be able to weigh that information against your budget constraints. Just because an ad is affordable, however, does not mean that it is going to increase your business; for instance, an ad won't help at all if it reaches the wrong age group of women. You must be selective when planning your campaign.

You can maximize your advertising-budget dollars by repeating your advertisements on a continual basis. One large advertisement with no follow-up won't bring you the kind of sales that a group of ads carefully placed at designated intervals in various publications can generate. Naturally, it takes some time to become accepted in any given locale, and I urge you not to become discouraged. A constant flow of advertising dollars will ultimately lead to an increase in your sales dollars.

After a while, you can begin to evaluate your advertising effectiveness in the various newspaper, magazine, and neighborhood publications that you have employed. After determining which ads have been the most successful, target your advertising dollars only for those publications that work best for you. Although neighborhood advertising may be a quick and easy way to advertise, it is not always effective since it tends to limit your audience. Make an effort to find out about the demographics, and the income brackets, of each publication's readership, and whether these publications are distributed primarily to men or to women. Ask the sales representatives who sell you your advertising space to provide you with this information. Your aim is to reach the right market concentration, not necessarily masses of readers.

When writing your advertising copy, customize it to fit whatever kind of media you are using. Advertising a weekly special may be fine for a local newspaper, but it will hardly have good application in a monthly magazine. Include your

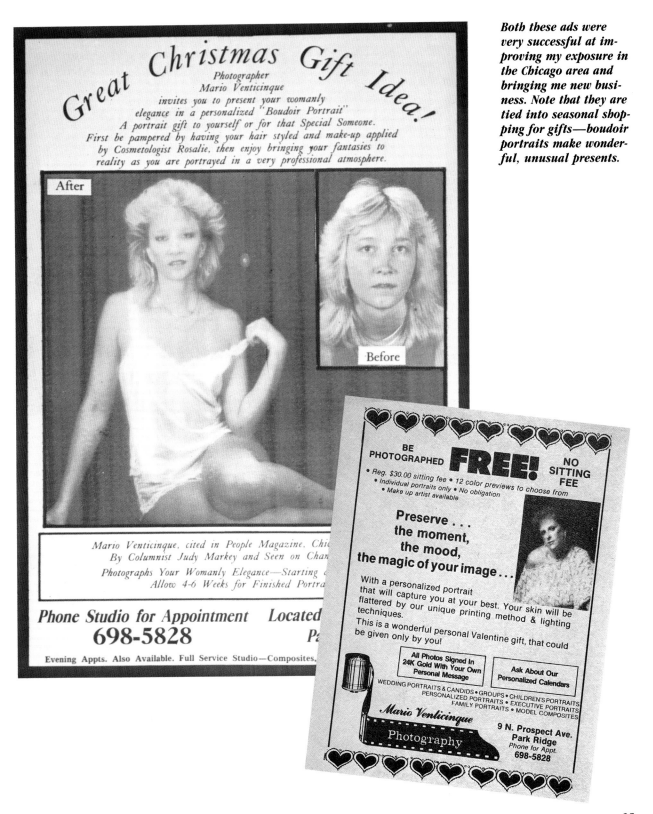

logo in all of your advertising to build customer loyalty and recognition, along with your hours and your location, and invite readers to call and inquire about your services.

Unlike many products that offer easy-to-visualize results, boudoir photography's benefits must be extolled to the ad's readers in order for a potential client to percieve herself in a boudoir setting. Keep your copy interesting, and make posing for a boudoir photograph sound like a fun and rewarding experience. By all means use photographs! Women want to see results, not hear about them. For this reason I have found that radio advertising is not as effective as using the printed page. Because photography is a visual medium, the best methods for advertising it are also visual.

I prefer to have a woman answer telephone inquiries and book my appointments for me, because it is reassuring for potential clients to hear another woman's voice. Since many women feel apprehensive about going through with a boudoir photo session, it is important for them to be reassured by hearing another woman, who helps them reaffirm their committment to booking an appointment. Never have your receptionist justify your prices. If the caller has a need for your service, she will be more than willing to pay the price.

PUBLICITY AND MERCHANDISING

Another great way to add to your credibility and stimulate sales for your new business is relatively simple and straightforward: contact local newspapers and inquire about the possibility of their doing a feature article on your boudoir photography business. Magazine publications are another avenue to free publicity.

Don't limit your advertising to the print media. Use some basic merchandising approaches in your studio itself. You can treat the windows of your studio as if they were giant pages in a magazine. Arrange portraits and signs to be viewed by people passing by. Merchandising is just another way to create a response. Make people talk! One effective way to guarantee that people will stop and take notice is to display unretouched before-and-after photographs—large-size photographs such as 20″

× 24″—that are well lit at night or whenever the studio is closed. Keep your windows clean, and change your displays at least once a month to show different arrangements and photographs. Try to put as many samples of your work as you possibly can out there in the public eye. Call health clubs, aerobic centers, suntanning salons, beauty salons, or any establishment catering to the needs of today's women.

Directories and Yellow-page ads are costly but effective, especially if you are able to offer specialty services that other photographers don't, such as custom framing, restoration, and having a makeup-and-hair artist on staff. The bottom line is to use your advertising wherewithal to get your message across to the consumer. As your business becomes more successful, it may be advisable for you to employ an advertising professional to develop a campaign for you, so that you can give full attention to operating your boudoir business.

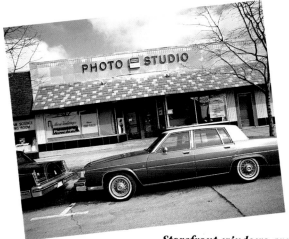

Storefront windows are made for displaying special services and products, and provide a flexible format for free advertising. They also give the public an opportunity to look inside at how professionally you run your operation. As you can see from the exterior shot of my studio (above) and this interior shot (right), I keep my window area neat.

36

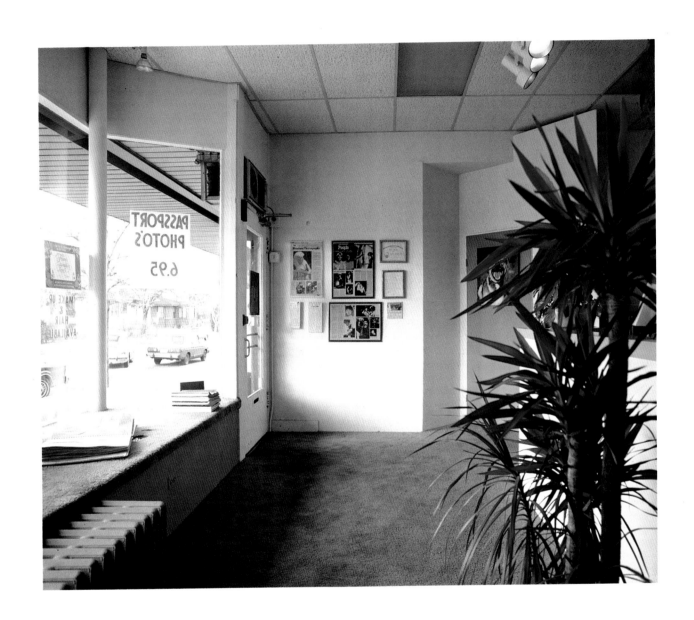

When nice girls pose for Mario, pictures are oh so tasteful

BY JUDY MARKEY

All you need to bring is chutzpah. The photographer supplies the rest. Boudoir photography is like that. You just come in and $75 later, your hair's been styled, your makeup's been done, you've poured yourself into the teddy, garters and boa of your choice, and you are about to become as sexy on celluloid as nice girls get.

Nice is the operative word. Boudoir photography is not porn. Mario Venticinque, who has been in the boudoir biz for two years, is adamant that nothing lewd has ever crossed his lens. Mario says "tasteful" about 11 times a minute when he describes it. We have your "tasteful" fur and corset combo (a 51-year-old mother of three wore that one), your "tasteful" full fishnet ensemble, your "tasteful" Fifi the French maid getup, and—admittedly at the outer limits of "tasteful"—we have "tasteful" leather and handcuff coordinates. Of course, what makes it all so tasteful is Mario's array of lens filters. Which get foggier and foggier in direct proportion to the cellulite and stretchmark quotient of the client.

That's the beauty of boudoir photography. It can transform your normal, averagely defective mortal into a scrumptious quasi-Cosmo cover girl. Which is why so many women across the country are going in for it. After years of watching the man in their life drooling over strangers in magazines who have been airbrushed into photo perfection, now they can even the odds. Boudoir photography is proof that almost anybody can be drool-able when she does a bit of cheesecake in front of a cheeseclothed lens.

"Everybody has at least one good feature," Venticinque says in his Park Ridge studio. "Hands, eyes, smile, shoulders. We just make the most of that and camouflage the rest."

Today's client requires less than the usual amount of camouflage. Jane is 27 years old, 5 feet 9 inches tall, and has the kind of long, lush, naturally blond hair even the Breck Shampoo girl would kill for. But you wouldn't know that until the hairstylist finishes with her. When Jane first walks into the studio, the hair is yanked back into a ponytail, and the outfit is the full hausfrau look—jeans, scuffed loafers, gray wool knee socks and a sweatshirt bearing the regulation amount of spit-up stains. Jane just had a baby. Six months ago. She gained a mere 68 pounds with the pregnancy and though she's dropped most of it, she still feels a bit lumpy.

But she's seen Mario's work and she knows he can turn her into a smoldering temptress. The picture will be a surprise for her husband, a high school calculus teacher. Surely if it weren't for him she wouldn't be standing there in only a pink lace teddy and goosebumps.

"How do you feel, Jane?"

"Naked."

But Venticinque knows his boudoir biz. And within half an hour, the teacher's wife is tossing her mane of hair around, dropping her shoulder straps, wetting her lips and come-hithering as if she were to the satin sheets born. "Boy," she says, laughing, "I'm really getting into this."

The phone rings. It's the baby-sitter. The kid is cutting a tooth and squalling and could Jane get home right away? Does Christie Brinkley have to put up with this? Probably not. But those are the hazards of being a temporary temptress. So Jane shoves her garters in her purse and hauls out the teething ring and prepares to return home.

Two sides of the modern woman—garters and teething ring. At least with boudoir photography the garter part gets recorded for posterity too.

Probably the best publicity you'll ever find is the word-of-mouth kind that comes from satisfied customers. Learning to respect your clients' reasons, whatever they are, for wanting fantasy portraits of themselves will go a long way toward guaranteeing your success.

THE CLIENT-PHOTOGRAPHER RELATIONSHIP

Introducing yourself as the photographer and greeting the client with a friendly "hello" is only the first step toward winning her trust. Your personable attitude will be the most important factor, and it should be present from your first contact with her. Building your client's confidence in you early on will dismiss her uncertainty about posing for a boudoir photographer. She should immediately perceive you as being outgoing, confident, and excited about the upcoming photo session, which will motivate her to be more excited, also. Let her know how much fun is involved. Try not to keep any barriers between the two of you. Your client may consider you to be like her hairdresser or her analyst, so your being an understanding listener is important to establishing a friendly relationship with her. Be prepared to support her with a positive and uplifting attitude throughout the entire two-to-three-hour photo session (including hair and makeup). The tone you set during your initial meeting will affect how smoothly the rest of your session goes.

A brief consultation can be done over the telephone when a client books her appointment. Tell her what to bring, how many changes of clothing are advisable, where the studio is located, the best place to park, that it is fine to bring a friend, and to arrive with clean hair and a clean face. On the day of her appointment, a more detailed consultation takes place. I don't schedule consultations prior to the day of the photo session, because they aren't economical.

THE CONSULTATION

After the client has entered the studio and you've greeted her, you are ready to guide her through your presentation, which you need to design to answer any questions she may have regarding boudoir photography. Then she will basically know and understand what will be happening to her during the photo session.

The presentation should occur in the reception area's comfortable surroundings, and can be carried out in a variety of ways: through slide projection, video recordings, or simply with photographs. You'll want to show samples of your finished work, including different background sets for the client to choose from, different poses, different character looks, certain special effects—soft versus sharp focus—and before-and-after photographs.

The photographer, client and makeup artist should all discuss the client's likes and dislikes. Any comments or suggestions she has should always be taken into consideration. You will immediately discover some of her preferences as she reacts to the samples you show her: "I like this, I don't want that." As the photographer, however, you should maintain control by saving untimely questions for the end, when you can address them without sidetracking the presentation. Remember that your goal here is to use this consultation to arrive at a consensus with the client.

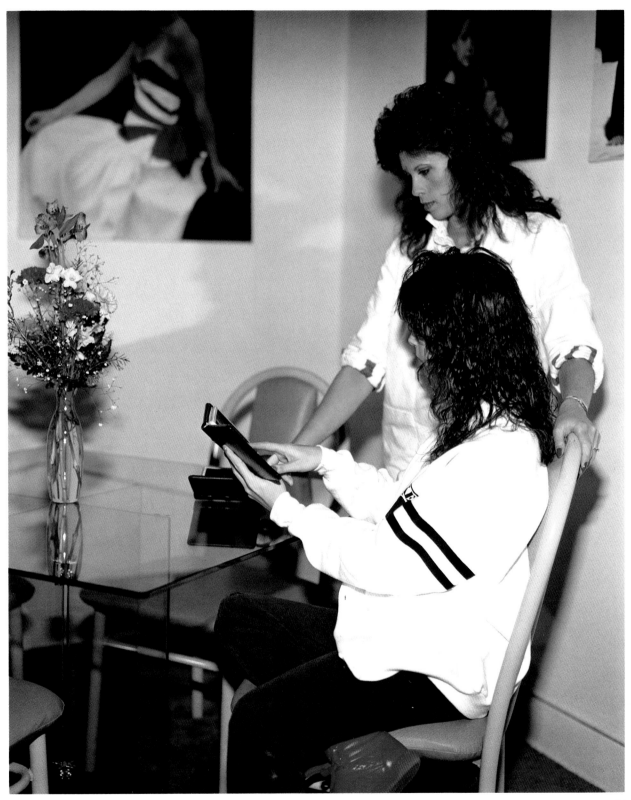

Older women are ideal candidates for boudoir photography, because they are usually more comfortable about their sexuality. They also exude an air of greater confidence about the fantasy roles that they portray.

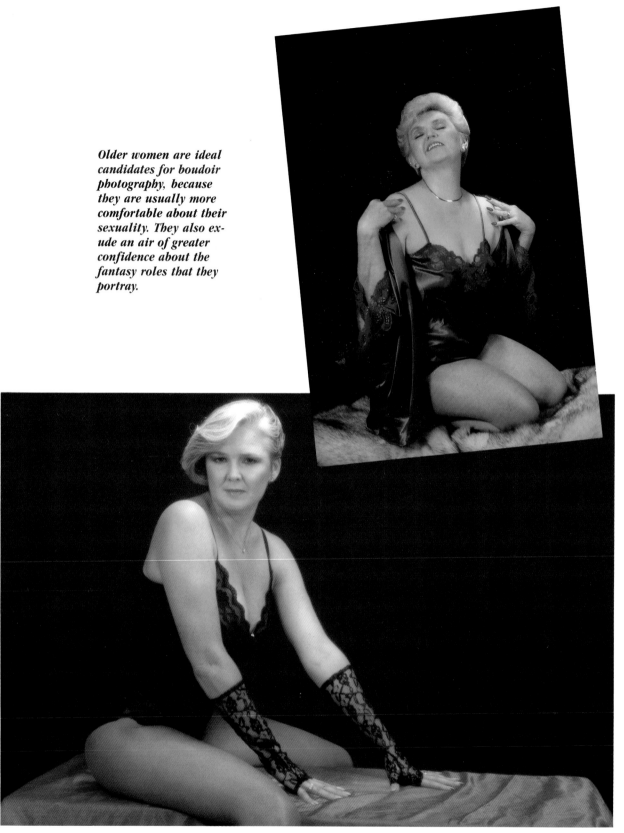

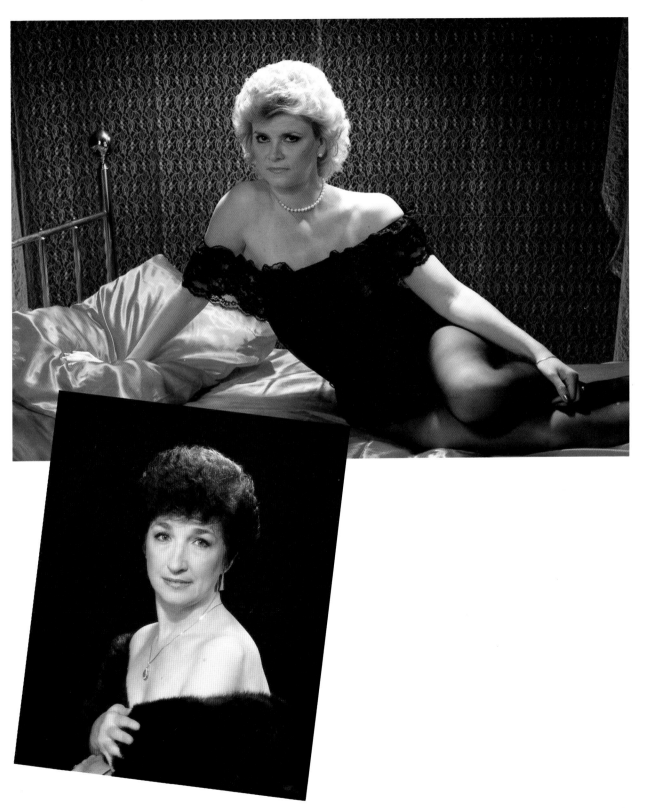

Although the client may want something very similar to a previous sample that she has seen (whether it be a sample of work that you have done or a picture she saw in a magazine), her pose and final photograph will be an original, because her own expressions and personality will come through in your photographs of her.

During the consultation, you will look at what she brought along with her, and she will almost always ask your opinion. Which do you like best? Which will photograph better? Which earrings go better with what outfit? Should she wear the red pumps or black ones? Acting as a friend but also as a knowledgeable photographer, you can advise her of the wisest choices.

Dear Mario,

I first thought about having a boudoir portrait taken of me so that I could give it to my boyfriend for his birthday. I was really nervous about the whole thing, but I just kept thinking about how surprised he would be, and how much he would enjoy it.

I never expected it to be so much fun! I really enjoyed the whole experience, from the makeup and hairstyling to the actual photo session. And of course Mark loved the pictures—so did I.

I'm glad I did it, not only for my boyfriend but for myself. If Mark and I ever break up, I think I'll make another appointment to have some more pictures taken.

Thanks again,

Belinda

Belinda

Dear Mario,

I was very apprehensive and nervous about calling you, but secretly I had been wanting some intimate photographs taken of me for a long time. I waited until I lost fifteen pounds last spring—and then I called and made the appointment!

Being greeted by someone as nice as Rosalie put me right at ease. Because everything was so relaxed and fun, I didn't feel funny about doing it at all.

And Rosalie made me look so beautiful! Best of all, she gave me some good tips about my makeup that I'm still using.

I'm planning to lose another ten pounds and when I do, you'll be hearing from me again. These photographs have worked wonders for my self-esteem!

Best wishes,

Georgia

Georgia

Your client will more than likely exhibit some timidity when showing you the lingerie. Reassure her that, in fact, bathing suits often cover less of the body than the lingerie that she has brought with her.

Sooner or later you will find out who she is doing this for, a boyfriend or a husband, and maybe for what reason. Boudoir photography is a great gift idea for the "man who has everything" (and even for those who don't). Your client wants to show someone that she, too, can look like those admired women in magazines. Very often she will keep her boudoir session a total surprise from her loved one, which is why I suggest having her contact the studio for any scheduling or delivery information instead of having the studio contact her and risk having a man answer the telephone.

The fact is, most women normally have boudoir photographs done just for themselves, to preserve their image right then at that time in their lives. Your client may be feeling wonderful about herself—perhaps she began working out and improved her muscle tone or lost a lot of weight, and is proud of the way she looks now. Maybe she is depending on your photographs for incentive to not gain the weight back.

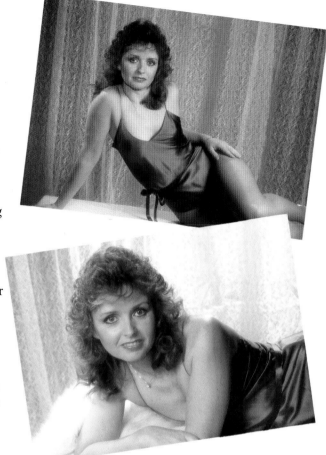

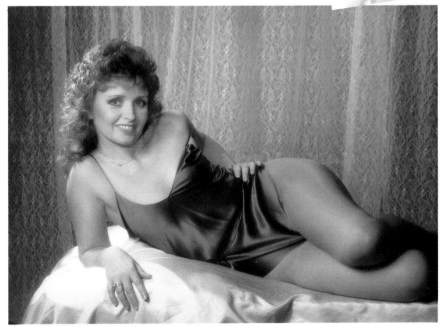

Don't assume that a client is having pictures taken for someone else—she is just as likely to want them as evidence of the positive way she is feeling about herself.

REVIEWING COSTS AND LEGAL CONSIDERATIONS

Always keep different-sized samples in the studio, and let the client know your prices for reprints, if she hasn't asked already! Show her the impact that a 20″ × 24″ photograph makes when compared to an 8″ × 10″. You may even suggest that she purchase a wall grouping of photographs or offer reasons for buying a large photograph versus buying many little ones. When going over prices (depending on your preferred method of business), let your client know of any specialties that go with the photographs; for example, if they are custom printed or if proofs are included. Explain to your client about proofs, since she probably won't be familiar with the fact that they aren't always the correct color or even that they can be cropped differently. You can explain the different ways to display them, such as being framed, mounted, stretched on canvas, hand oiled, or placed in folios.

After the client has seen your work, understands her options and is becoming familiar with the world of boudoir photography and with you and your staff, she will more than likely relax and be at ease. At this point, you can introduce her to the studio itself, to the lights, the backgrounds, and the props, which are all exciting and new to her experience. Keep her thrilled with the whole idea by explaining that she is about to have the experience of a lifetime, to feel completely pampered and be the sole focus of all this attention. This is the time to thoroughly enjoy herself. Try to help her to forget everything else around her, so she can live out this fantasy to its fullest.

Before you go any further, before makeup is applied or hair styled, and before the actual shooting begins, we highly recommend that your client sign a model release, such as the one on the next page. This will protect you from any conflicts with the client, and will put her mind at ease. And having an employee (your makeup-and-hair stylist) with you throughout the photo session will protect you against any false accusations.

The colors in this photograph looked very different when first shown to the client in proof. Explaining to her how the colors would look in the final print helped me make a sale.

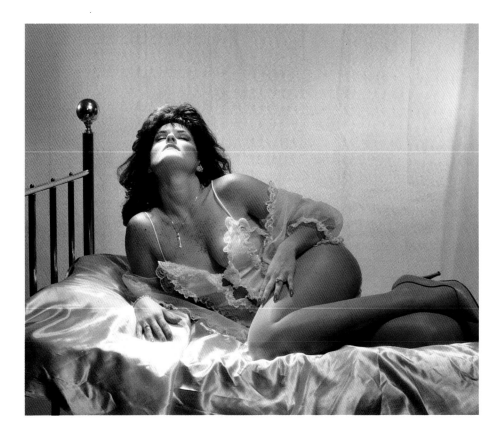

46

Model release

For and in consideration of my engagement as a model for Personalized Boudoir Portraits, hereafter referred to as the photographer, on terms or fee hereinafter stated, I hereby do not give the photographer, his legal represntatives and assigns, those for whom the photograher is acting, and those acting with his permission, or his employees, the right and permission to copyright and / or use, reuse and / or publish, and republish photographic pictures or portraits of me, or in which I may be distorted in character, or form, in conjunction with my own or a fictitious name, on reproductions thereof in color, or black and white made through any media by the photographer at his studio or elsewhere, for any purpose whatsoever; including the use of any printed matter in conjunction therewith unless otherwise stated in contract.

I, the model, hereby will not discharge photos taken by the photographer, his representatives, assigns, employees or any person or persons, corporation or corporations, for whom he might be acting. The photos are not to be sold or distributed as a finished product, in whole or in part. I will not blurr or alter, or use in composite form, either intentionally or otherwise, or in any type of publication.

All photos are to be used for personal use only.

I, the model, give Personalized Boudoir Portraits the right to use finished photos, as samples for display purposes only.

I have read the foregoing release, authorization and agreement before affixing my signature below, and warrant that I fully understand the contents thereof.

client: _____

studio: _____

I hereby certify that I am the parent and / or guardian of _____, an infant under the age of twenty one years, and in consideration of value received, the receipt of which is hereby acknowledged, I hereby consent that any photographs which have been or are about to be taken by the photographer, may be used by him for the purposes set forth in original release hereinabove, signed by the infant model, with the same force and effect as if executed by me.

Parent or guardian (L.S.) _____

address _____

9- NORTH PROSPECT AVE
PARK RIDGE, ILLINOIS
PHONE FOR APPOINTMENT
(312) 698-5828

Personalized
Boudoir
Portraits

By Mario Venticinque

M AKEUP AND HAIRSTYLING

The makeup-and-hairstyling session, or makeover, is intended to transform your client's appearance from her everyday look to the glamorous, boudoir look you are trying to achieve. Doing a quick overview of her physical attributes during her consultation is the first step in developing a cosmetic plan tailored to her individual needs. You'll want to characterize the client's assets and liabilities in an organized manner. Begin by studying her facial construction, her expressions and her features. Does she have high cheekbones? Laugh lines? A small or large forehead? and so on. Examine her from head to toe, noting any problem areas. Pay attention, finally, to her personality type, whether she is shy, hard-looking, soft, elegant, seductive, or a cutie, and use it to underscore whatever look you decide to develop.

MAKEUP TECHNIQUES

When choosing makeup from the products available, you and your stylist should remember only to buy makeup that fits your photographic needs and is comfortable for your clients to use and wear. Some clients may not be accustomed to wearing a great deal of makeup in everyday life, so be reassuring to those who don't. Tell them that the camera actually diffuses the makeup's effect, which is why wearing exaggerated makeup at a photo sessions is necessary.

When buying makeup, color should be a primary concern. Look for eyeshadows in numer-

ous and dramatic shades, and apply the same criteria when selecting foundation makeup for the skin and when choosing eyeliners. Another consideration should be how easy the makeup is to apply. Eyeliners, for example, need to be soft enough not to pull the skin, and foundation colors should be relatively easy to blend with each other and onto the face. Keep a broad selection of these various cosmetics on hand, since having some that your client recognizes will be reassuring for her.

SKIN COSMETICS

It is really helpful to learn how to recognize skin types, because each type requires a specific strategy to offset or correct its special problems. Dry skin needs moisturizing, whether by using an oilier foundation, cream blushes, or a simple, moisturizing face cream. When your client has oily skin, astringents can be used to remove excess oil, and the face can be powdered to prevent shininess. Scrutinize the client for imperfections like extensive freckles, blemishes, broken capillaries, or blotches, which can all be treated cosmetically. After determining your client's particular type of skin, the makeup artist is ready to begin the makeover.

Foundation makeup camouflages any imperfections in skin tone, and it leaves the skin evenly colored. This makeup creates a smooth and flawless surface for the camera to record. Foundation color should be as close as possible to the

Essential Cosmetic Accessories for Your Studio

cotton balls

cotton swabs

cosmetic sponges

eyelash curler

shadow brushes

blush brush

powder brush

eyebrow brush

lip brush

blow dryer

two curling irons:
a mini and
a three-quarter
barrel

hot rollers

combs and
hair picks

hair pins

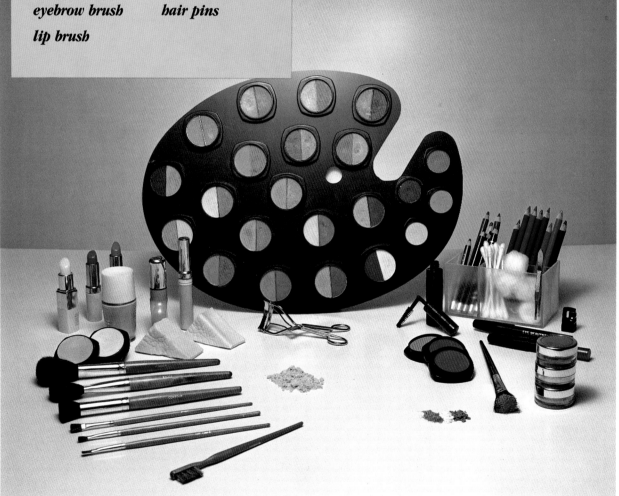

This woman's makeup is very understated yet well suited to her soft, delicate appearance. Her eyes, in particular, seem to have a natural glow that makes them the focus of the photograph.

client's own skin color. If a specific skin type is pinkish, however, we suggest mixing a foundation that has a bit of yellow in it to counteract the pinkish hue; conversely, if the skin is naturally olive or yellow, add a touch of pink or red.

When applying the foundation, blend it out and away from the features into the hairline, down under the chin, and down the sides of the face. Foundation should be spread across the entire face, including the eyelids (which prepares them for applying eyeshadow, since foundation prevents eyeshadow particles from falling off, and makes the eyeshadow adhere better). Never use thick foundation on a woman who has facial wrinkles—the foundation will actually deposit itself in the wrinkles and lines, thereby intensifying and drawing more attention to them.

If there are flaws, such as bruises, on other parts of the body, you can try to correct them by applying a white foundation and then a skin-tone foundation over the white. Scars need to be covered with a skin-tone foundation. Unfortunately, scabs cannot be hidden by makeup—they must be retouched in the photograph. Makeup alone can only faintly diminish some body flaws, but coupled with special camera and posing techniques for camouflage, makeup can aid tremendously.

For accentuating certain areas, highlighters are ideal. Because highlighters are designed to reflect more light than ordinary skin tones, the camera records them more strongly, thereby making the area they cover look more prominent. Most typically, they are used to make cheekbones stand out, which is simple to achieve by dabbing highlighter above each cheekbone and below the eye. A small amount of highlighter applied around the chin will help keep it from receding. To compensate for close-set eyes, add highlighter in-between the eyes across the ridge of nose. To narrow the jaw, apply a small amount of highlighter around it. To make a wide nose appear narrower, draw a line of highlighter down its center. Concentrating highlighter on the tip of a stubby nose will elongate it.

Highlighter should be a couple of shades lighter than the client's own skin color. Foundation can be used as highlighter as long as the color choice is accurate, but many special highlighter products are available. Carefully blend highlighter into the skin, and avoid making the wrong areas too prominent.

The following contouring techniques are suggested strictly for photographic purposes. Used correctly, this kind of shadowing results in a sculptured, structured face, but use it sparingly and only when absolutely necessary. Contouring the face is especially dramatic in black-and-white photographs.

You can contour cheeks, when they need to be diminished or for a more hollow appearance, by applying a darker shade of foundation underneath the cheekbones and blending it down the sides of the face. Contouring can be used to make a wide nose appear narrower by applying a darker shadow to its sides. To shorten a long nose, touch up its tip with the darker contouring shadow, or diminish a double chin by adding contouring to its underside. Prominent chins can also be diminished by dabbing a small amount of shadow onto the chin itself.

Blush is literally a blush of color, and it is usually applied right above the hollows of the cheeks by blending it from the ball of the cheeks out toward the ear and into the hairline.

Loose powder has a variety of final-touch uses: it gives the client a matted, "cover girl" appearance, and it hides perspiration. Without powder, many unwanted highlights would be revealed and picked up by the camera. Apply compact power under the eyes to minimize shine in this frequently oily place.

BEAUTIFUL EYES

Next, focus attention on the eyebrows. I suggest that you beautify the eyebrows before applying eyeshadows, so that you will know exactly where the brow bone is. Then you can more easily determine where you want to put your eyeshadow.

Some eyebrows may need only a little brushing, while other require darkening to add fullness or extra length. And some women may need to have the entire eyebrow drawn in.

Full eyebrows generally need tweezing below the brow bone to create an arc that follows the bone's natural arch. Carefully remove extra hair on the brow bone—otherwise the light reflected by the

The difference between this client's skin tones before using foundation (left) and after makeup (right) is amazing! Using a bright blush on her cheeks also helped to pull attention away from her badly mottled chin and up instead to her eyes.

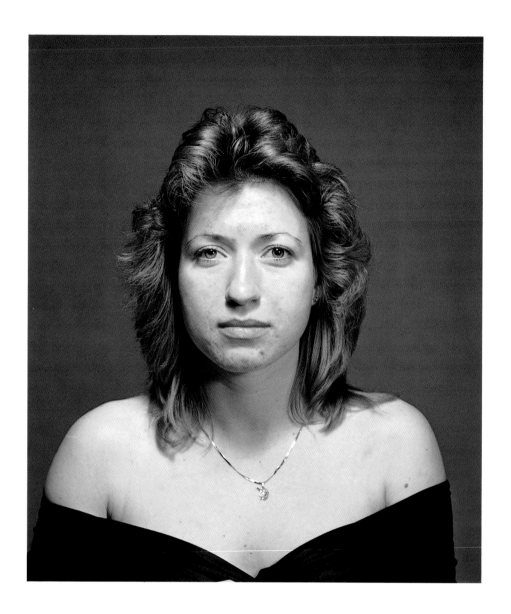

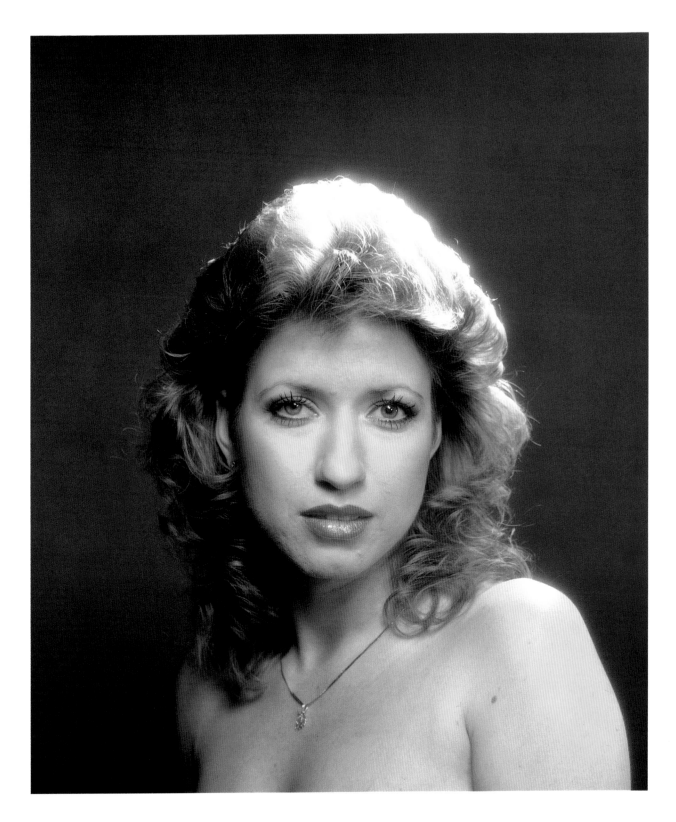

This client needed a good foundation to cover all the little imperfections that stood out in contrast to her very fair skin. Pulling her hair away from her face and contouring her cheeks with highlighter reshaped her entire face.

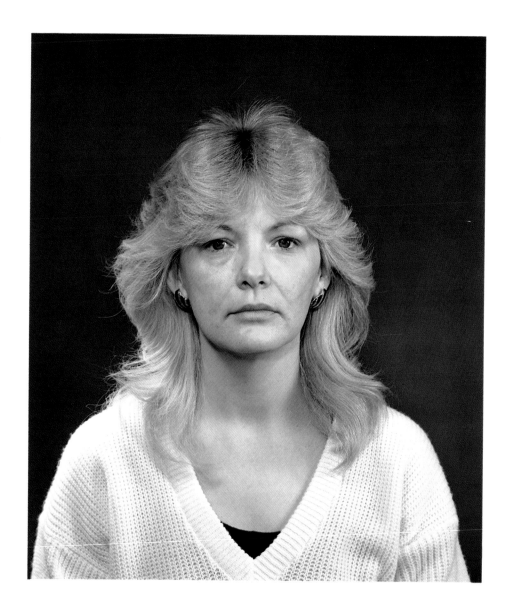

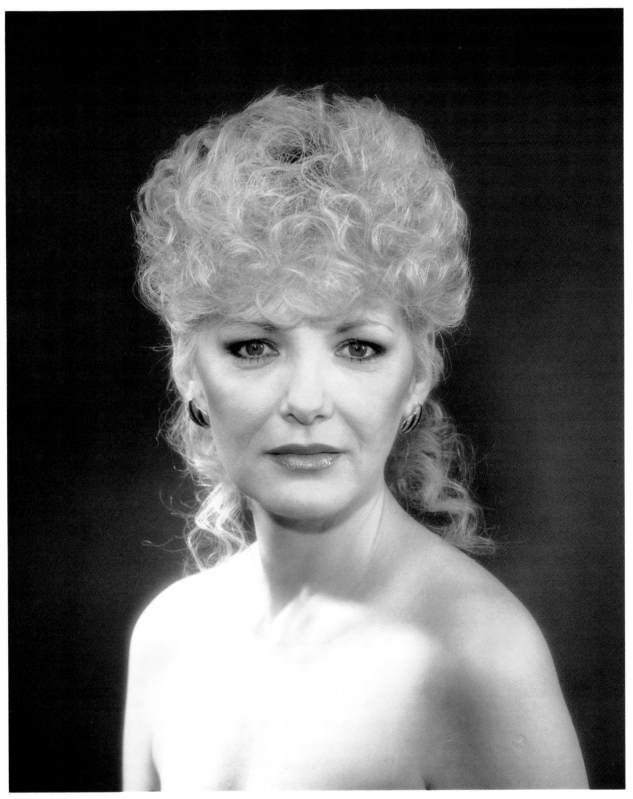

55

Round faces without well-defined chins can be dramatically altered through the use of highlighter, which was applied to this client's chin and above her cheekbones. Then blush was added to contour the sides of her cheeks, bringing a new shape to her face, perhaps for the first time ever!

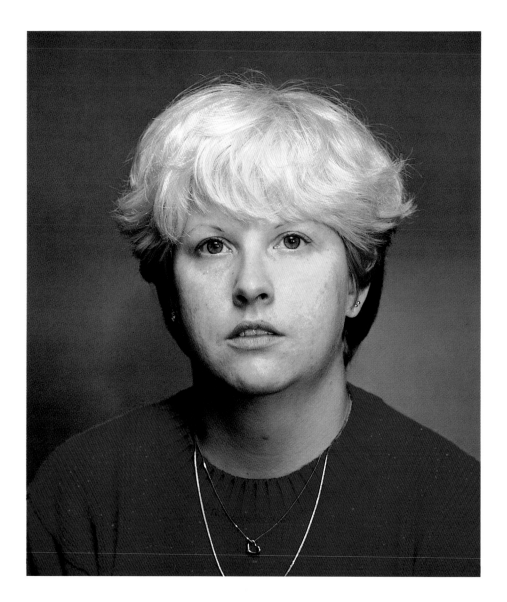

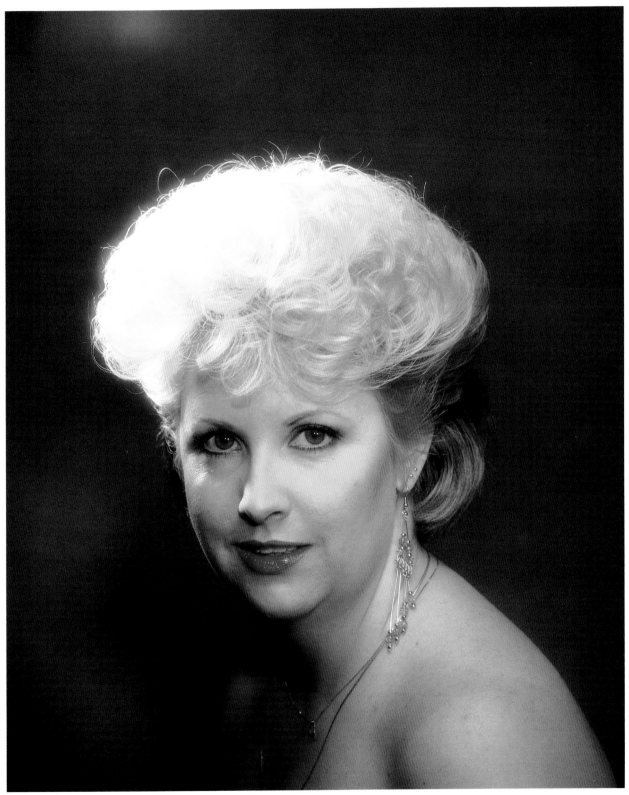

The eyes are a client's most important feature because they are the most expressive. Before makeup and hair styling, this client's eyes weren't extraordinary—but after applying eyeliner and eyeshadows, they seem to glow with an inner light.

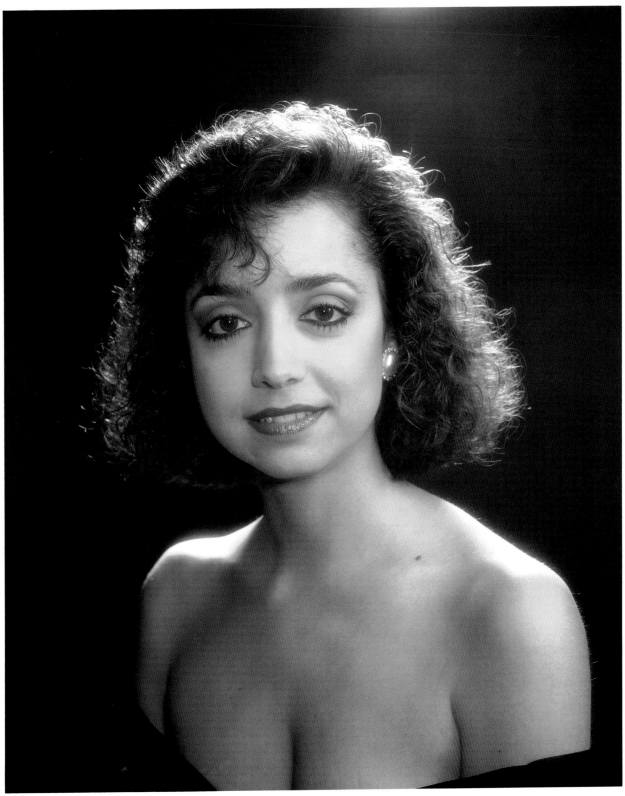

*Thin lips look es-
pecially lost when set in
a wide face, but they
are easily recovered
with a little bright lip
color. Contouring this
client's face also helped
to refocus attention on
her other features.*

When Rapunzel let down her hair, my stylist created a look worthy of a starlet bound for Hollywood! Women love what this makeover uncovers in them, so sometimes they come again looking for a second transformation.

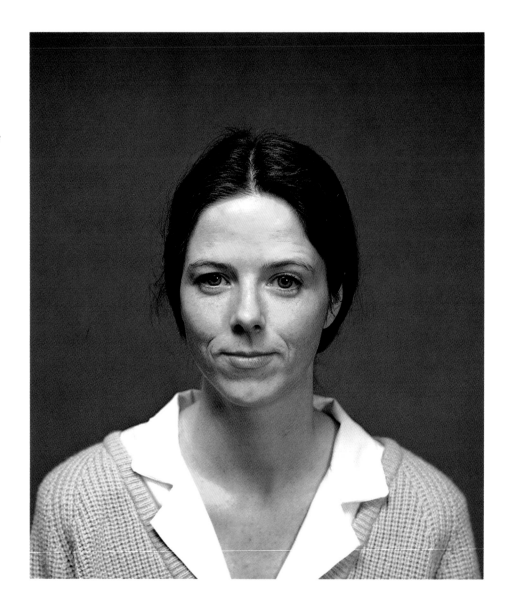

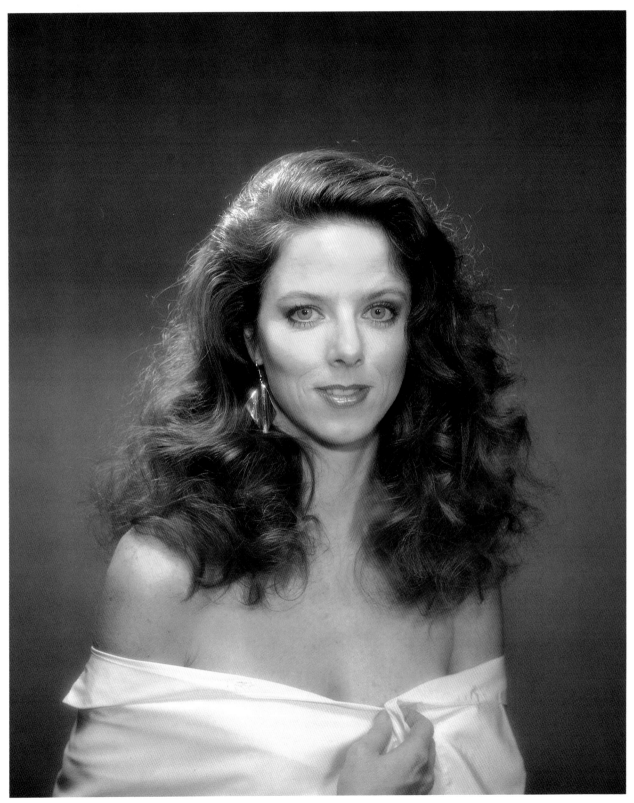

63

Long, straight hair makes a narrow face look even longer. Curling and fluffing this client's hair reproportioned her face and helped soften her look considerably, giving her an irresistible, feminine allure.

brow bone will diminish, causing it to disappear in shadow. An eyebrow pencil can be used to fill in scarce spots by making soft, short strokes in the same direction as the hair grows. (This also applies when adding an entirely new eyebrow.) Eyebrows should start right above the inside of the eye and extend to, but not beyond, the outside corners. Eyebrow color should match hair color unless hair is blonde—then the eyebrows should be slightly darker. When the eyebrows are groomed, you are ready to apply the eye makeup.

In boudoir photography, giving the eyes a lot of attention is essential, because with the right eye makeup, the client's eyes can be expressive enough to carry the final photograph. Today, eyeshadows and eyeliners are available in a wide array of colors. Use them to your utmost advantage—they create the dazzling and dramatic looks that are synonymous with boudoir photography.

A client who wears contact lenses should remove them before putting on eye makeup. This will ensure that dust particles from the makeup don't get into her lenses and make her eyes tear, ruining the makeup already applied.

When applying eyeliner, I prefer first to outline the entire eye by drawing a soft, thin line on the top lid, which thickens the eyelash line, and then drawing a smudged line on the bottom. To define the eyes, concentrate a darker line in the outside corners. Applying the liner to the inside corners of the eyes is only necessary if your client has wide-set or bulging eyes that need to be brought together. You can use an eyeliner color that is different from the color of the client's eyes. Eyeshadow can then be applied over the eyeliner.

Apply the darkest eyeshadow colors to the crease line, extending them in a triangular shape straight out almost to the eyebrow. Put medium-range colors on the eyelid, reserving light colors (or perhaps no color at all) for the brow bone.

There are techniques for recasting certain eye shapes. When the eyelid is small, you can extend light-to-medium colors up above the eye crease, and then put a darker color above the light color to mimic a higher crease, which elongates the eyelid. When the eyelid is large, put the dark color used for the eye crease slightly beneath the actual crease to give the illusion of a shorter eyelid. To enhance round eyelids, extend eye-

shadow a touch beyond the corner of the eye. Deep-set eyes will benefit from using a lighter eyeshadow to bring them out. To correct protruding eyes, darken them and they will recede.

Applying mascara to the eyelashes is the final step in eye makeup. Use black or brown mascara for a natural look. Brush on the first coat after applying the eyeshadows, and do a second coat after the facial makeup is completed. The last coat of mascara is applied to thicken eyelashes and to conceal any loose particles of shadow or powder stuck to the lashes.

Here is a list of basic eyeshadows that coordinate well with natural eye colors:

Blue eyes	Shades of gray are the best choice, but muted blues, purples, and browns also do well.
Green eyes	Browns and rusts are ideal for enhancing green; however, as an alternative, try using purples to make the eyes more vibrant.
Hazel eyes	If you want to bring out their green tones, use brown shadows. To accent their blue tones, use grays.
Brown eyes	All colors work well with brown eyes; however, we prefer to use deep rose and wine colors.

LIP COLOR

Lips are an extremely sensual part of the face. When their makeup is complete, you will be able to see the satisfying results in your client's smile.

Use lip liner to contour and define the lips if a definite and natural line isn't already present. If the lips are uneven or too thin (top, bottom, or both), then line them just outside the edge to make them even. If the lips are too full, a line just inside the natural lip edge will help reduce them. Always be sure to match these added lines with the chosen lipstick color.

The lipstick color used should coordinate with the client's other makeup colors, which should in turn harmonize with the rest of her boudoir portrait. To achieve a soft and natural look, use

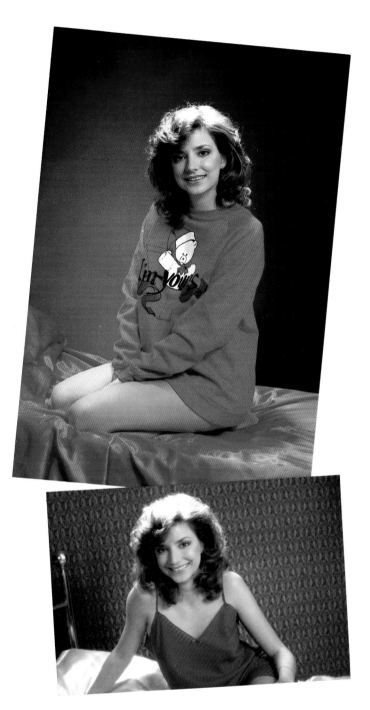

light and airy lipstick colors; for seductive, vamp-ish looks, dark or red lipstick is more appropriate. Then apply clear gloss over the lipstick, so that the texture of the mouth will be highlighted for the camera. If your client's lips are very wrinkled, don't use gloss.

HAIRSTYLING

After completing the client's makeup, next analyze her hair according to its color, texture, length, and cut. Whatever hairstyle the three of you decide to use should be in keeping with the way in which the client wants to be portrayed. Remember to respect the client's wishes—if she prefers not to have any extreme changes in her normal appearance, then make only minor changes.

A client with a long, narrow face generally should be given some fullness on the sides of her head, and some hair needs to fall across her forehead. This approach works best if her hair is at least chin length. As an alternative, suggest that she wear her hair up. For a client with a full face, remove hair from the sides of her face or slick the sides back; either method will help elongate her face by removing some of its width.

Since all of this preparation is for a camera shoot, it is important to pay close attention to certain unusual details. When hair is combed back for fullness, be sure that your stylist doesn't leave any sparse areas that your camera will see through. Be conscious of keeping the client's hair uniform all the way around her head, and don't allow unruly strands of hair to fly away—the camera will easily detect and magnify them.

Allow at least forty-five minutes to complete the entire makeover transformation, which will give the client enough time to relax and enjoy anticipating the upcoming boudoir session. When she moves into the actual photo session, you'll want to make a final inspection of her appearance. Although I sometimes spray a woman's body with water to set up a swimsuit shot, last-minute nervous perspiration is unwanted. So take a good look at your client under actual studio lighting to ensure that her skin is dry and that her makeup is doing what you intended it to do. Be ready to alter it slightly, if necessary, when you are both finally on the set.

It is easy to coordinate makeup colors with a client's wardrobe, even if she poses in several different outfits, be-cause makeup and clothing should both be keyed to her own natu-ral palette first. This client's warm skin tones and dark eyes look wonderful with her berry-colored lipstick, which coordinate well with the colors in both her outfits.

Plan to discuss your client's wardrobe and accessories with her during her consultation. Most clients will bring their own change of clothing, which is fine because that will give you an idea of what each client prefers. Although the client might initially feel apprehensive about wearing certain lingerie that she finds "too daring," experience has taught me that during her transformation from housewife to cover girl, she will assume a new character and a freer attitude toward her sexuality. So it is a good idea to keep a few articles of lingerie in the studio, in case she isn't satisfied with what she brings.

When purchasing lingerie, try to buy durable garments (since clients will be trying them on repeatedly) and remember that most women are not petite. Look for clothing that is versatile. Long robes and peignoir sets, for instance, are designed to be loose fitting and they should fit almost anyone. Collect a variety of totally different looks and you'll have something on hand for everyone. Garter belts and hose, ruffled teddies, and even simple slips or exercise attire can be ideal when matched with the right client.

During the actual shoot, don't forget that you aren't doing a fashion ad for lingerie—the client should always stay at the center of your attention. Her clothing and accessories are merely adjuncts used to highlight your boudoir composition. The color, texture, and style of her outfit do, however, play an important role in achieving the total look that you and your client want her to convey.

COLORS AND TEXTURES

Your makeup-and-hair stylist will be a great help at coordinating your client's hair, skin, eye color, and makeup. The stylist will understand how pastels create a soft, pretty image, while black and red suggests a ripe, seductive, and somewhat harder look. Blacks and rich, dark colors are also helpful for hiding unwanted bulk and discoloration in heavier women. To break up uniformity or to offset the lack of contrasting colors in an outfit, have the client tie a colored ribbon around her waist or ask her to pose with a fan, a boa or another colorful prop.

The fabrics most commonly used in lingerie are soft, silky, and satiny materials that serve to help clients feel sensuous and to put them in the correct frame of mind for boudoir photography, so that their innermost expressions shine forth.

The lingerie a client wears must flatter the shape and contours of her body. Wearing bulky, flouncy materials tends to make a plump woman appear much heavier. A slim good-figured woman can enhance her best features with a tight, clinging garment.

Ruffles, pleats, and shiny materials can be used to play up highlights for the camera, and to create shadows with the proper lighting. And I have found that combining sheer fabrics with various special lighting effects can produce the illusion of seeing the body's contour, which is somehow more tastefully erotic than total nudity.

Photographing white lingerie against a white background produces the most delicate boudoir results. To prevent focusing on any shadows that might have fallen against the background, I opened up my lens, and to further soften the image, I diffused the lens somewhat.

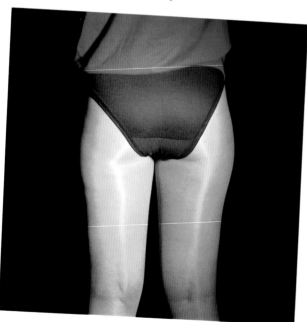

Pantyhose are excellent for correcting and covering leg problems, such as the cellulite on the hips and thighs in this "before" photograph (above). Wearing pantyhose, the same client's legs look sleek and firmer (below).

LINGERIE AND CLOTHING STYLES

As I mentioned earlier, I normally formulate a wardrobe plan during my initial consultation with the client. Given her preferences, I envision the best ways of utilizing the various styles of lingerie and props that she wants to use to accomplish the assignment.

Some lingerie styles are as useful for camouflaging as they are for enhancing certain features. For example, a long, flowing peignoir set on a stout woman is much more flattering than a clinging teddy, because the peignoir set lengthens as well as conceals her girth.

Lingerie with high-cut sides will elongate the legs of a shorter woman, while a woman with long legs should avoid that style and instead choose a garment with a fluttering bottom that rests lower on the leg. Slim women can wear just about any style, as long as it showcases their figure. They should, however, avoid the loose, oversized items that make them appear boyish and as if they have no figure at all.

Although lingerie is the most common wardrobe choice in boudoir photography, there are endless combinations of other clothing and accessories that can be used. Very often clients will allow me to make an imaginative suggestion, such as wearing a bathing suit and body oil, and having dripping wet hair, which can look very racy.

Fur coats are the most elegant boudoir attire, and can be draped over the client to expose bare shoulders, legs, or selected areas. Older women may find this idea especially appealing—wearing a fur coat documents status as much as it may hide body flaws.

Younger, athletic-looking clients sometimes want to use T-shirts or tank tops with french-cut bikinis or with Jockey cottons. The sporty look emphasizes the fun-and-cute, yet sexy, side of this kind of client. It is important to have this type of treatment available at your studio, since it provides an alternative to lingerie for women who are not the lingerie type.

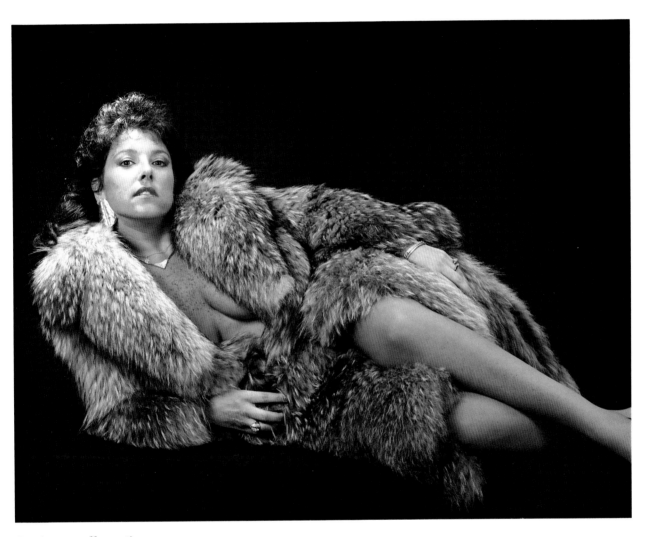

Fur is naturally erotic,
and because of its
weight and bulk, it's an
ideal material for cam-
ouflaging major figure
problems.

Dear Mario,

Choosing a photographer was not an easy task. I was afraid about what they would expect from my appearance, and whether or not I would be a laughing stock! I had always stereotyped photographers as being aggressive and unfeeling.

Watching television one evening during the week before Valentine's day, I saw an interview with you about your studio. I liked your style and manner, so I called. Your receptionist explained what would be expected of me, and how I should decide beforehand what type of look I wanted to portray.

Upon arrival (with goodies in hand), I took one look at you and started to leave. Do you remember me saying, "You could have helped out by being short, fat, and ugly!" I felt threatened by your good looks, but you were most supportive and down to earth, and assured me that my nervous state was quite normal. You really eased me into feeling comfortable.

At that point, you introduced me to Rosalie, your hair-and-makeup artist, who can transform an everyday, ordinary-looking thing like me into someone who is seductive and extraordinary-looking. I was extremely impressed by her expertise. She also made me feel comfortable, and constantly reassured me during one-and-a-half hours of preparation.

Needless to say, it was a very titilating experience. Every woman dreams of being this immensely gorgeous creature, and in all honesty, this short fantasy with you was an extremely rewarding experience. I not only felt good about how I looked that day, but the real reward was when I received the proofs. My husband was astonished by how fulfilled they made me feel. He wanted me to do more! I'm looking forward to posing for you again, and have recommended you to all my friends.

Love,

Jeannie

Jeannie

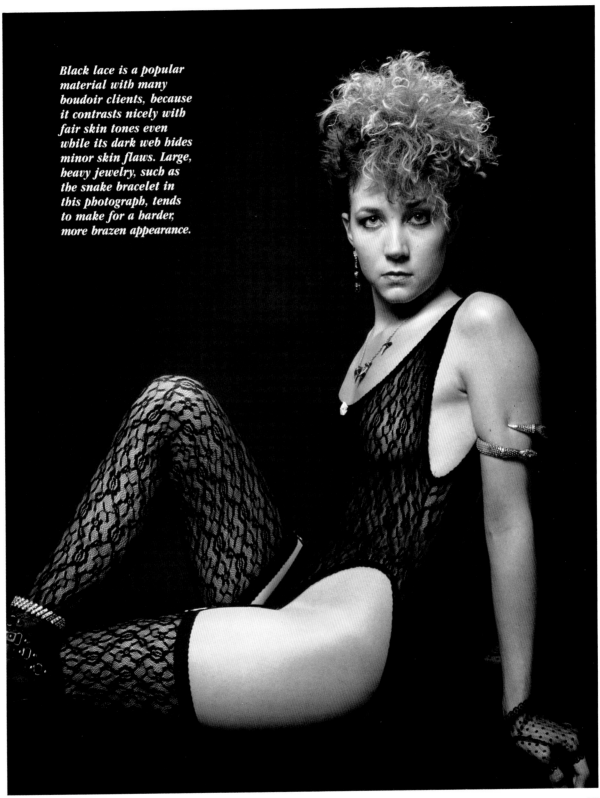

Black lace is a popular material with many boudoir clients, because it contrasts nicely with fair skin tones even while its dark web hides minor skin flaws. Large, heavy jewelry, such as the snake bracelet in this photograph, tends to make for a harder, more brazen appearance.

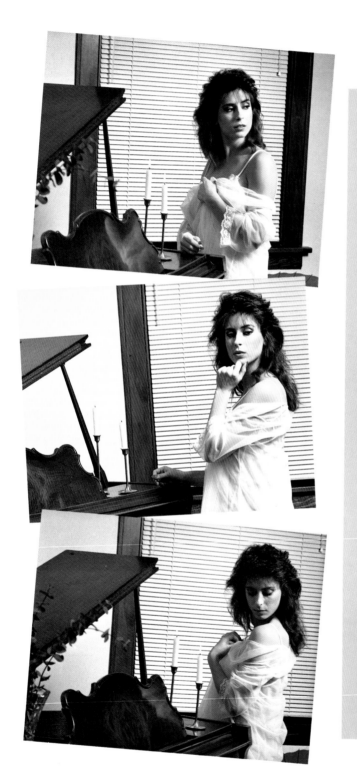

Editorial versus Portrait Photography

One thing to keep in mind when photographing boudoir portraits is that portraits aren't meant for publication as an editorial spread in a magazine. A good portrait must focus on the individual who is the subject, not on the lingerie or jewelry she might be wearing.

Editorial work, on the other hand, describes fashion or illustrates a point of view. The models used in an editorial shot often don't look into the camera's lens, because the models are of secondary importance in the composition.

In these photographs, Michelle's pose by the piano would be acceptable for editorial purposes, but the overall composition is not what most boudoir clients want. In my opinion, these photographs are too commercial looking for personal use. Using too many props on a set can create the feel of commercial advertising, rather than that of an intimate portrait. Most of the time, simplicity works best in a boudoir composition. The boudoir client should always be the main ingredient in the photograph, not the props or the set.

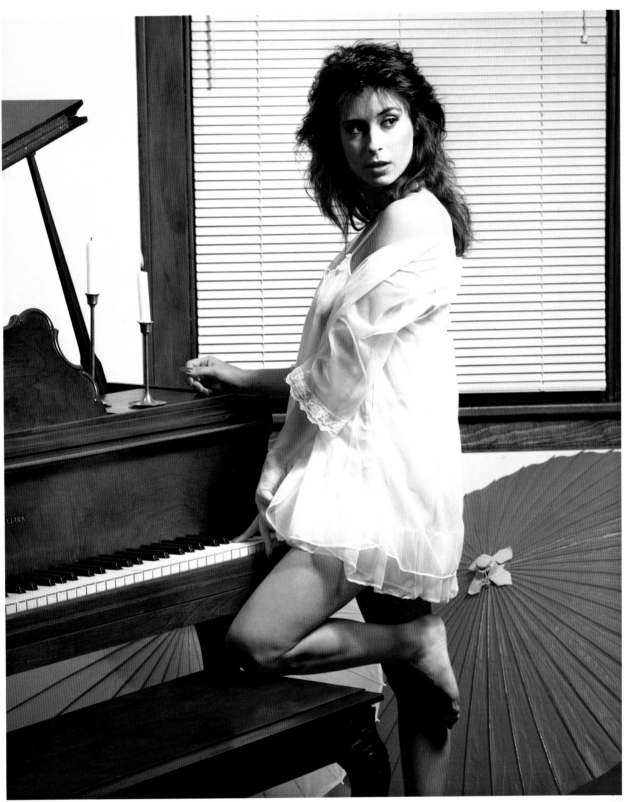

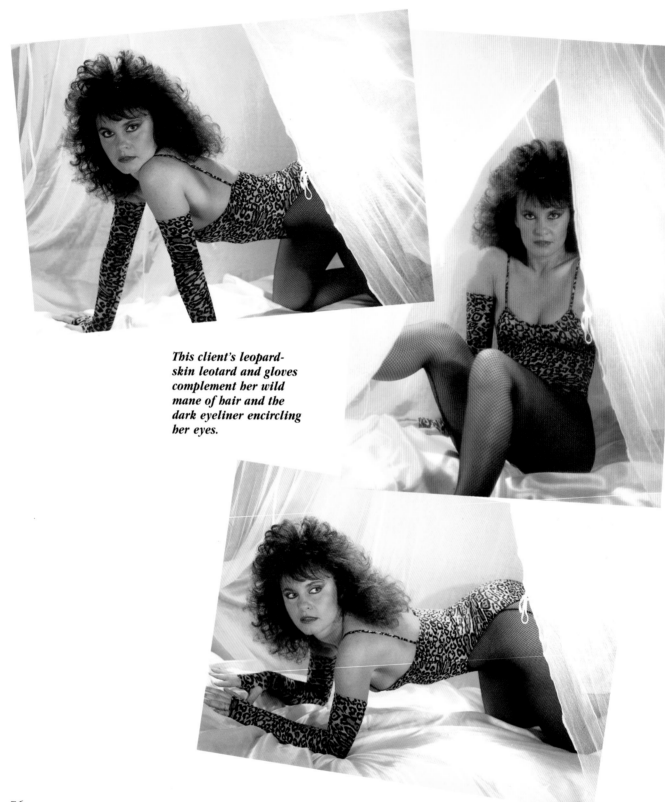

This client's leopard-skin leotard and gloves complement her wild mane of hair and the dark eyeliner encircling her eyes.

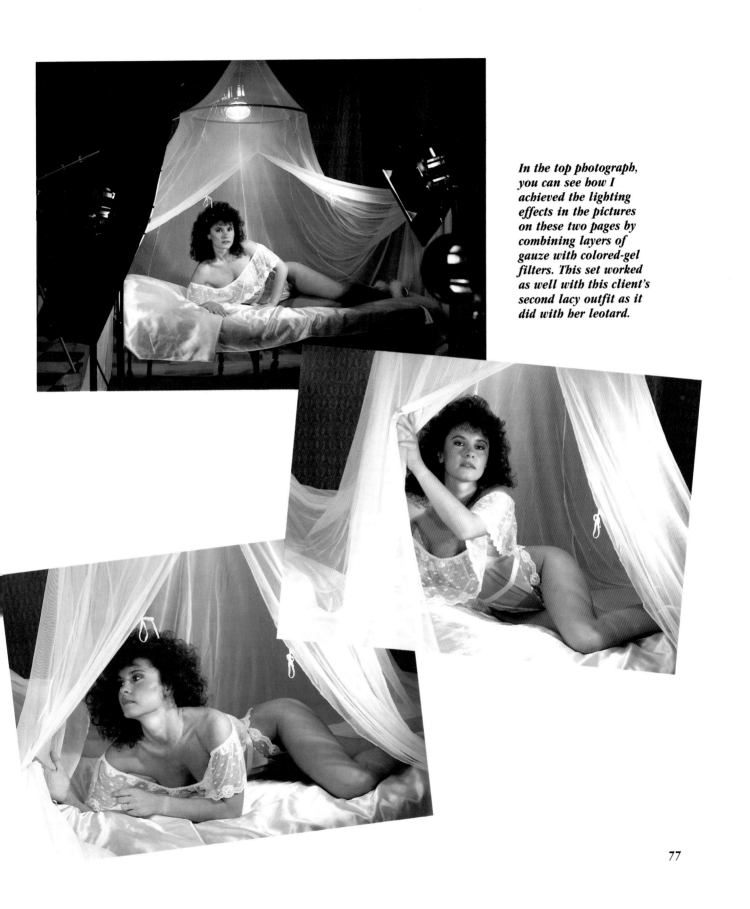

In the top photograph, you can see how I achieved the lighting effects in the pictures on these two pages by combining layers of gauze with colored-gel filters. This set worked as well with this client's second lacy outfit as it did with her leotard.

ACCESSORIES, THE FINAL TOUCH

After determining how the client is going to dress, add accessories to tie her look together. Necklaces, earrings, bracelets, and rings are wonderful, glittering props that can be manipulated for highlights or played with by the client. Be sure to discuss jewelry with her. She may have a special piece that she wants to include for sentimental reasons.

Pearls and delicate jewelry look best when worn with soft, natural, pretty looks, while bigger and wilder jewelry can enhance bolder, harder looks. A sophisticated look can be established by using sparkling jewelry, such as diamonds.

The shape and length of earrings and necklaces can aid in correcting problems in body proportions, such as uncommonly short necks, long necks, full, round faces, or long faces. For women with short necks, choose longer-length necklaces. For those with long necks, choose shorter necklaces. A full, round face can be complemented by a pair of earrings that are long and narrow.

Attempt to coordinate your client's footwear with her choice of wardrobe. High-heeled pumps look great with garter belts and vampish looks. Marabou bedroom slippers with their trimming of soft, downy, feathers go well with a dreamier costume. For sporty, casual looks, bare feet may be fine—but make sure they are clean!

Legwear is essential whether your client wants a bare or textured look. Panty hose that are sheer from the toe to the waist will flatter your client's legs by providing extra support that enhances muscle tone. Panty hose is particularly good at camouflaging cellulite, and it makes leg color seem more uniform by hiding unsightly features, such as small veins, bruises, or purple discoloration from poor circulation. Fishnet stockings with seams are excellent accessories for creating a provocative, sultry look, and textured or sculptured hosiery complements the sophisticated look.

All of these accessories should be used to enhance the visual impact of the boudoir composition. Don't be afraid to experiment with your client's suggestions, or to explore new ways of using intimate apparel to complement the sensual flavor of your boudoir portraits.

Some women like to pose with stuffed animals, which adds a touch of innocence to boudoir photographs. Here the animal's fur picks up highlights in the client's hair.

White fur makes a dramatic statement against a black background. It also softens this client's otherwise angular looks.

Dear Mario,

I was very nervous at first—I mean to dress like that in front of a man I had just met! I brought so much stuff with me that I had a friend help me carry it into the studio. My friend was not just there as my valet, but as my moral support as well. What would I have done without her!

I have never been really excited about the way other people do my makeup, but this time I really liked it. When my hair was finished, I felt more relaxed, and confident that everything was going to go well and be a lot of fun.

Then it was time to change clothes and learn how to pose. I had always practiced in front of a mirror, you know, just goofing around, but I had never let anyone see me. I wore a total of four different outfits and found I became more and more relaxed with each one. The poses were very tasteful, not embarrassing at all.

Here are some helpful hints for your future clients based on my experience:

1. Save your favorite or most revealing outfit for last. I found that I was much more relaxed by the end of my session.
2. Trust your photographer and his assistant—they do this for a living. They know what will look best.
3. Bring a friend (a close friend); she can help you get dressed.
4. Plan ahead, and lay your clothes out at home the night before; some might need a little pressing.
5. If you have long fingernails, polish them! They will show up.
6. *RELAX!* Yours is not the first body this photographer has seen, nor will it be the last.

After the last photo was taken, I was a little disappointed that it all had to end. I have been encouraging my friend to give it a try. It was a great shot in the arm for my ego.

Thanks a million,
Mario.

Kathy
Kathy

LIGHTING STRATEGIES TO ENHANCE THE FACE AND FIGURE

Professional photographers need to experiment with their strobes to discover what it takes to create and enhance certain moods. Lighting enhances the ambience of a portrait. Used correctly, lighting can either highlight or de-emphasize facial features and expressions.

When you first begin to experiment or test, I recommend that you start by using one light. Work your light source around the subject clockwise while taking pictures from the same vantage point, thereby documenting the results on film to see what happened to the shadows and highlights as you moved the light. You will soon realize very soft to dramatic effects can be accomplished using just one light.

After experimenting with moving one light horizontally around the subject, move the light to experiment with it at various heights and angles. Eventually you will be able to visualize the end results before you even turn on the light. If the availability of light-heads is limited, try using a flat as a light source to fill shadow areas and to augment your existing light-head.

If you use a flat with a white, dull-matte surface, your light will be flat, creating very little contrast. Flats made of gold mylar will reflect a warmer light onto the subject, which will create a brighter glow. Silver flats will add higher contrast to the photograph and sometimes, depending on distance, act like a mirror, causing undesirable hot spots. A silver flat will also help to clean up your shadows, if it is placed correctly. Black flats are used to prevent flare from leaping into the lens and can be used on both sides of the camera lens, or they can direct light to create the kind of falloff that you want. Combining a white and a metallic surface creates more contrast and reflects about twice as much light back onto your subject as a simple white surface can reflect.

Remember that boudoir photography is glamour photography, so your lighting options should be dramatic, ranging from lively to moody. The lighting selected should also meet your client's needs, which you can ascertain during your consultation with her. Keep in mind that using more than one light source in boudoir photography always leads to more dramatic and meaningful portraits.

Because most boudoir clients are not professional models, the boudoir photographer must perfect some method of camouflaging body flaws. The solution that works best for me is shooting boudoir portraits against black backgrounds. Lingerie comes in all colors, but most women bring at least one black garment with them to my studio. Photographing black on black permits the photographer to hide specific parts of the subject's body depending on how she is lit. For example, if a woman has an oversized waist, lighting the upper portion of her body will allow the lower body from the waist down to blend into the background. Underexposing the black background by ¼ stop will virtually eliminate her waist problem, as well as any stomach bulge or large hips.

To capture this client's beautiful, rich skin tones, I used a Prisma light-box with a grid to soften the light, and a hair light to outline her full head of hair. The lighting and exposure allowed detail to emerge in the buttery-soft folds of her leather outfit.

81

Here the model is lit by one Prisma light-box placed directly beneath the lens, and pointed upward at her. In addition to the ghoulish ambience created by this lighting method, look what happens to her nose!

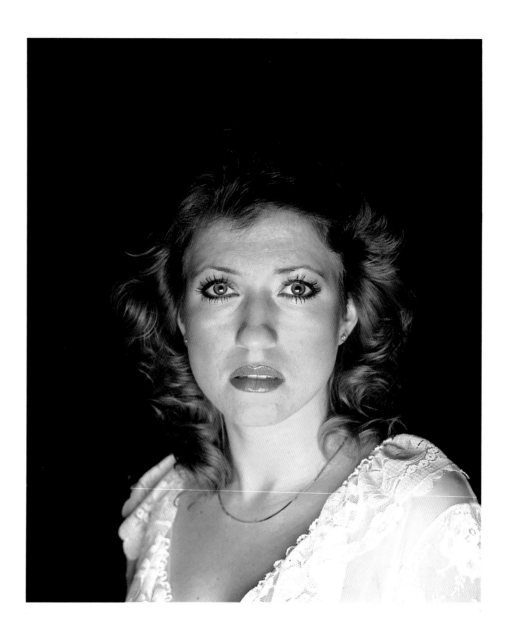

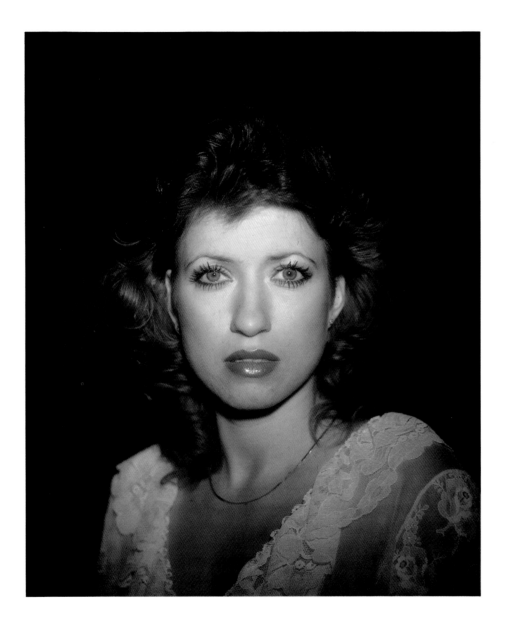

Problems with the model's nose and with facial puffiness disappear when the model is lit as above. I placed one grid-spot above and behind the camera, and directed light straight onto her face.

83

Here a Prisma light-box is placed at eye level and to the right of the model, which throws the left side of her face into total darkness for a mysterious, dark-side-of-the-moon effect. The harsh light on the right of her face amplifies its flaws.

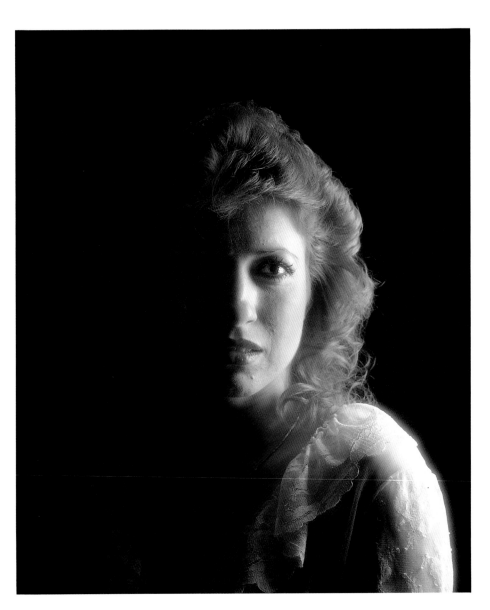

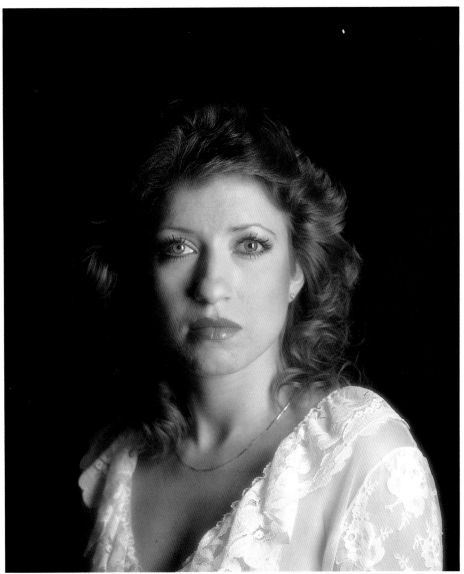

*Used at a 45-degree an-
gle to the model, the
Prisma light-box creates
a finely sculptured,
classical portrait look.
This lighting would not
be appropriate, however,
for anyone with deep
wrinkles or skin folds,
because of the shadows
cast across the skin at
this angle.*

Combining a Prisma light-box, used eye level at a 45-degree angle to the model, with a white fill card placed close to her face on the other side, results in less dramatic, more natural lighting. This kind of light is especially appropriate for use with a diffused lens, because the light is even without being flat and casts less shadow than without the white fill card.

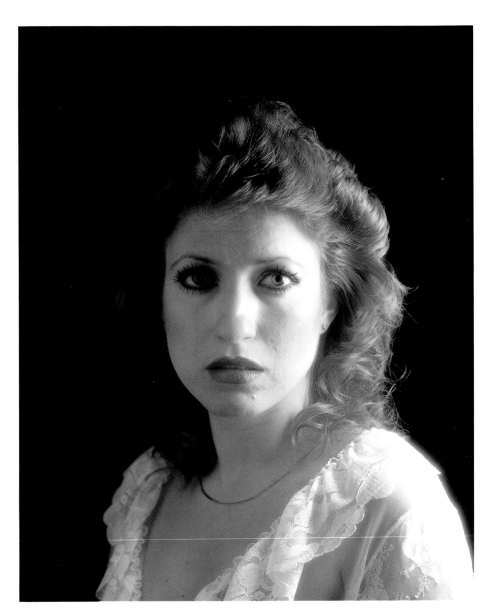

Two sources of light illuminate the model here: a Prisma light-box placed in front of her and slightly to the left, and a grid-spot placed above and slightly behind her head. The grid-spot outlines her hair and arms with an edge of light, while the Prisma light-box throws a soft, diffuse frontal light across her and highlights her left cheek.

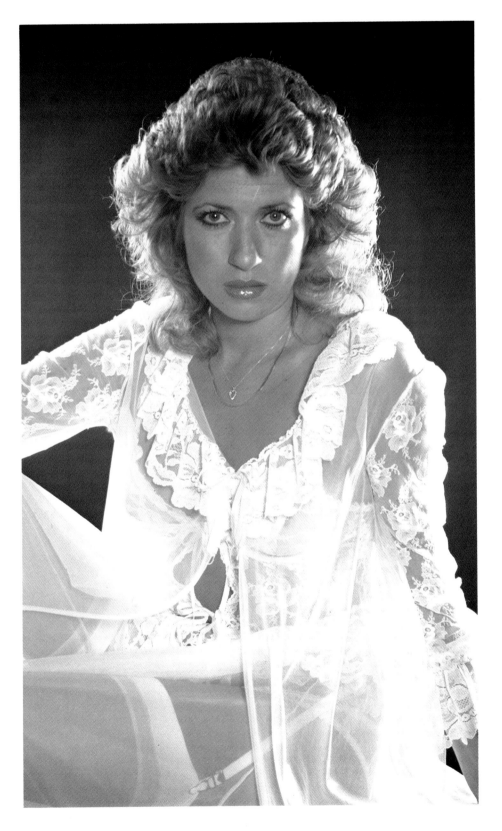

BACK AND EDGE LIGHTING

Most lingerie is translucent, so when light passes through it from behind a subject, the light will outline the figure. You can use back lighting to create a flowing feeling if the shape of your client's body warrants attention, or you can back light her hair, which will dramatically frame her face. For a large, overweight subject, don't back light the full figure—back lighting will emphasize the client's width and will outline her slightest bulge!

Edge lighting is very effective for flattering large women. Used correctly, edge lighting will outline only one side of the figure, letting the opposite side blend imperceptibly into the background.

Edge lighting can hide unsightly bulges wherever they occur on the figure. This client had a protruding stomach (below, right) so I employed a grid-spot at eye level and to the right of the client, which allowed her left side, including her stomach, to fall off into total darkness.

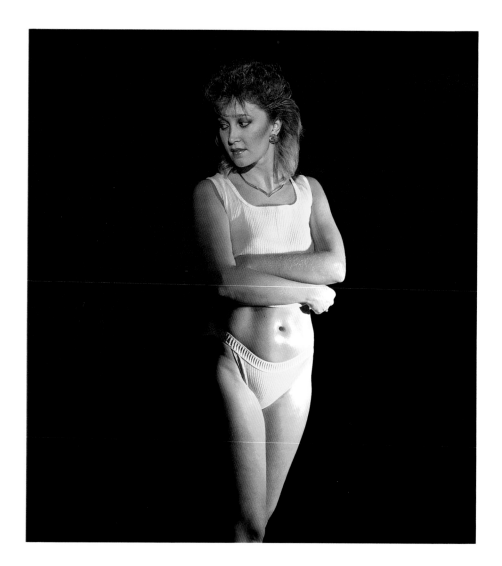

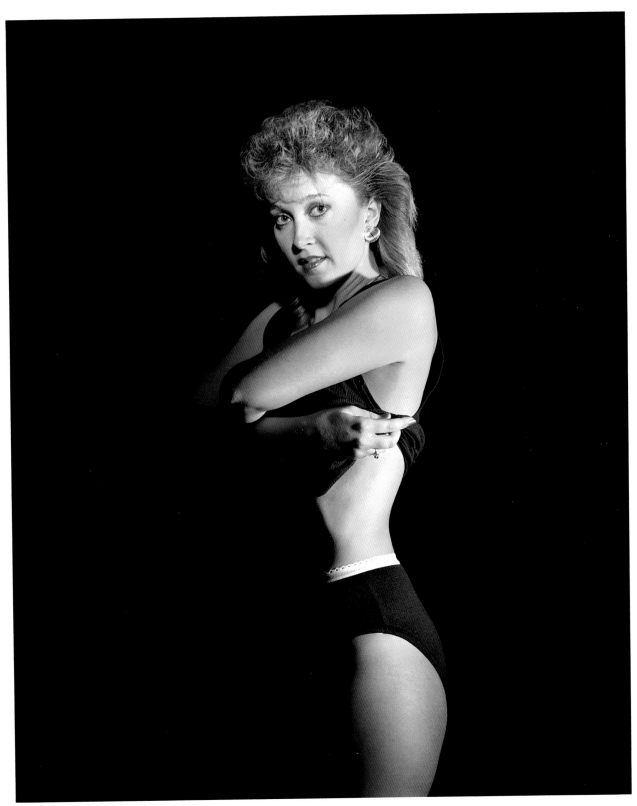

CLASSIC NUDE AND SILHOUETTE LIGHTING

Classic nude-figure lighting can also be utilized for photographing women wearing lingerie. This kind of lighting will emphasize the shape and form of the client's figure, and cast a delicate, classic shadow effect across her body.

If a client wants a more dramatic, completely nude study done, I employ what is known as silhouette lighting, which is fundamentally the same as classic nude lighting except that you must choose an *f*-stop that will separate your subject from your background material.

Success in lighting nudes relies heavily on the degree to which it is suggestive rather than revealing. No figure, no matter how appealing, is perfect, so the photographer must be careful about how much flesh is exposed to bright light. To create these silhouettes, I exposed for the background, and the figures dropped out in contrast.

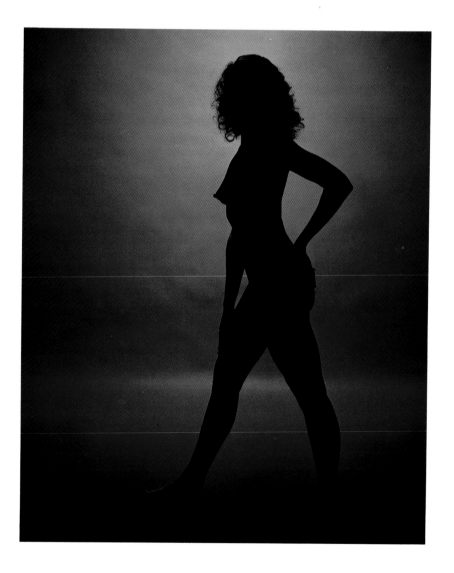

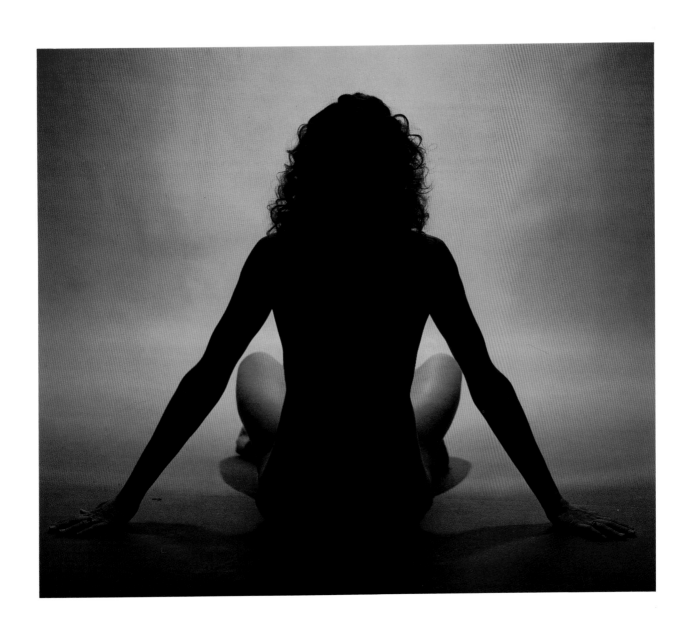

These photographs illustrate the difference between using a sharp lens and using a diffused lens. I made both photographs by placing one large Prisma lightbox to the left of the client and a white fill card to the right of the client. I used the same exposure for both photographs; but when I made the one on the right, I diffused the lens by stretching white cheesecloth over it. Lens diffusion brings a soft glow to portraits, and is a great technique for reducing skin flaws.

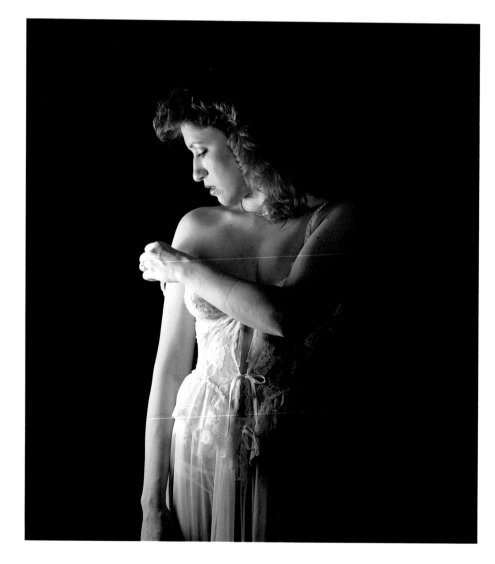

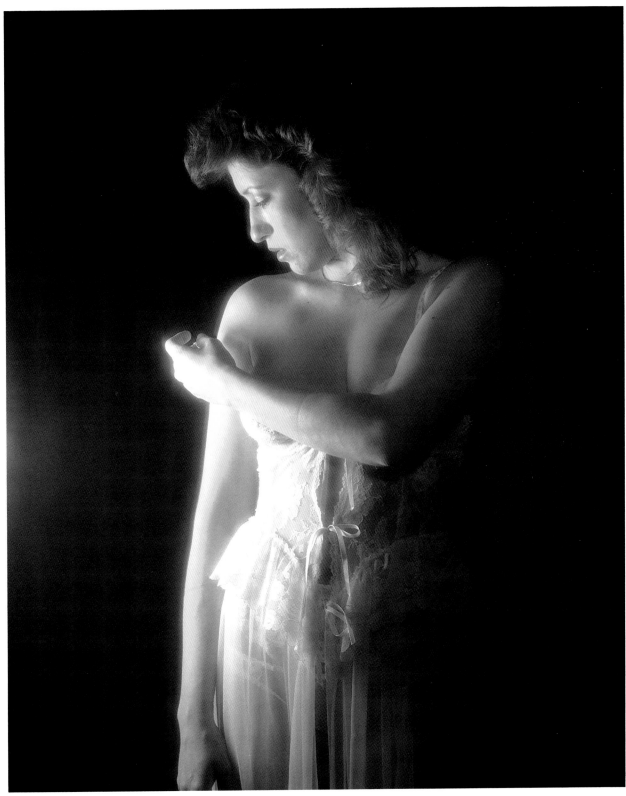

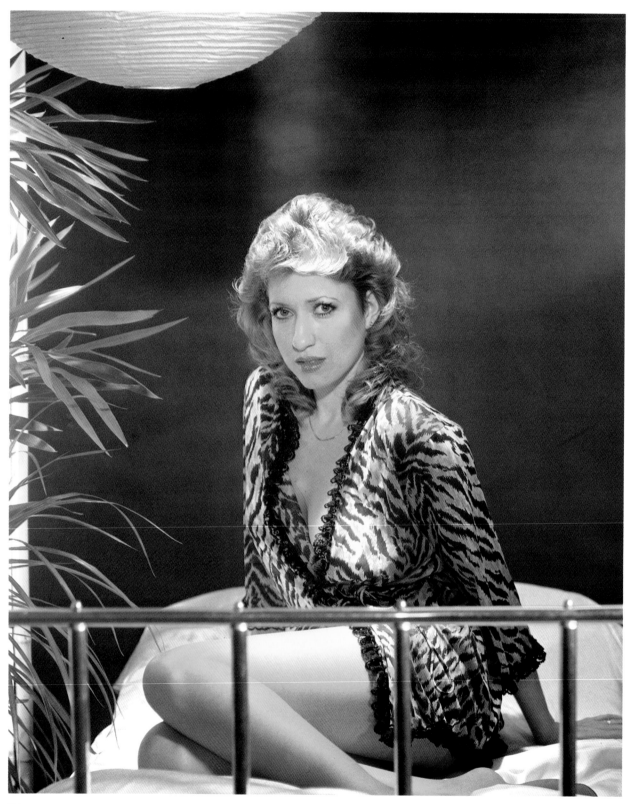

BOUDOIR MOOD LIGHTING

I've evolved this technique specifically for boudoir photography. Mood lighting combines the use of lights and filters to create an emotionally charged atmosphere in the final photograph. To achieve this effect (shown opposite), begin by positioning your main light behind and to the right of your subject, so that this backlight hits her hair and the left side of her face, thereby outlining her profile. Then use a full light on a flat to bring out the detail on the front of her face. This lighting method creates an image that is by degrees brilliant and mysterious. If you develop this style of lighting, you will find that it can be used on different subjects for many different reasons.

LIGHTING RATIOS

Understanding lighting ratios is critical in boudoir photography. These ratios are formulas that indicate the difference in output between the main or key light, and the fill light. Using a 3:1 ratio, for instance, means that the main light is three times brighter than the fill light. This is the ratio most commonly used in portrait lighting. When photographing people, I recommend that you select any one of the lighting ratios listed to the right.

If your client is in great shape or if she just doesn't want a black background, then I suggest you use high key lighting on a white background. To make this work, the light source for the background must be at least four to eight times brighter than the main light on your subject. Only light that portion of the background that will actually be in the photograph. High key lighting will minimize any flare or loss of contrast in the subject, while keeping the background pure white by preventing the grayish-blue cast that sometimes occurs.

You can achieve any desired illumination in your photographs by carefully selecting and manipulating accessories for your light-heads. The main light is usually brighter and harsher than the fill which should be diffused. Combining your main light with an umbrella or a Prisma light box will give your photographs good highlights that "pop." If you don't have a light box, use a curved umbrella with a bare flashtube pointed at its center. For the softest illumination possible use a white

Background Light versus Main Light

4:1 or 5:1	*These ratios are good to use when your subject is low in contrast, or whenever there is a need for higher contrast.*
3:1	*This is the ratio used for most portrait work.*
2:1	*When your subject is high in contrast, this ratio will help correct the imbalance, and it works well whenever there is a need for lower contrast.*

umbrella with the light-head placed close to it. For contrast, use a flat silver umbrella.

Control your lights—don't let them control you simply because you have become comfortable with one way of using them. Be versatile—experiment, test and develop your lighting techniques. To be successful, you must be creative enough to supply the client with a portrait that only a professional photographer could do, not her husband, her boyfriend or a friend of the family. This will allow you as a studio owner to demand and get good prices for your unique work.

THE PHOTO SESSION

After the client's makeup-and-hairstyling session is finished, she then changes her clothes in the dressing room and finally moves onto the set. You should have a basic repertoire of standard sets on-hand to complement and coincide with each client's wardrobe selection.

THE SET

You can collect an assortment of basic items (such as a brass headboard for doing reclining portraits on a bed, a Victorian vanity table, satin sheets and pillowcases, a full-length, stand-up mirror, folding screens, and plants) to create a variety of atmospheres for different clients. As your business progresses, you'll be able to afford to develop sets as elaborate as those designed for the stage, if you so desire.

My own preference is to use a simple, black, seamless-paper sweep. I think that photographing against a black background produces a much richer and more elegant portrait, and it enables me to focus clearly on the client, whose skin tones are much more visible against black. I design my set right on the paper sweep, allowing a distance of at least one foot, preferably six feet, between the background and the subject; any closer and unwanted shadows fall on a background that won't record as a true black.

The addition of special props such as parasols and plumes, and of special lighting effects, such as different-colored lights, further serve to facilitate a custom design for each client. Props can be added as they are needed, whether for atmosphere or as cosmetic aids to hide unsightly features and bulges that ultimately detract from the total composition.

Be sure that you know how many costume changes the client has with her, so that you can allow an adequate number of proofs per outfit. Remember, use good judgment and if it means shooting more film—do it!

MODELING YOUR CLIENT

The client should be made aware of what takes place during the photo session, so give her some preliminary information on what kinds of poses you envision her using during the session. It is a good idea to employ a light sense of humor, especially when the client isn't yet adjusted to the shoot or the settings.

Before beginning the shoot, take time to explain how you would like your client to move. Facial changes are best when the client moves extremely slowly, for example from left to right without breaking eye contact with the lens. If she moves her head up and down, and from side to side in slow motion, it will give you a chance to see different angles and views through the camera, so you'll be able to decide on the best perspective. This "slow motion" positioning of the face and head works wonderfully with nonprofessional models, and increases your quota of useable shots.

Here is the studio area where I assemble sets and do my shooting. A gray seamless-paper sweep is set up on the left. I prefer using paper sweeps for background material, and overall, I like to keep my sets simple. This allows me to focus completely on the client and not be distracted by peripheral elements.

These three clients are all posed the same way—lying on satin bedsheets, with one leg over the other—which is a very flattering position for photographing most women.

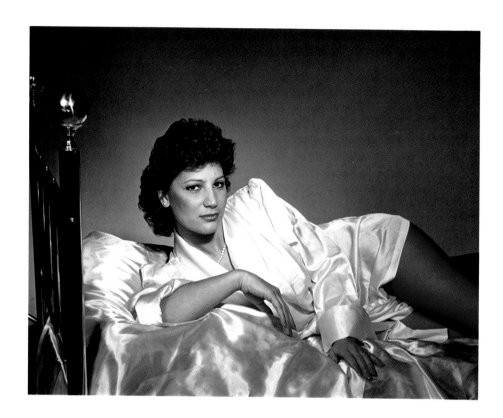

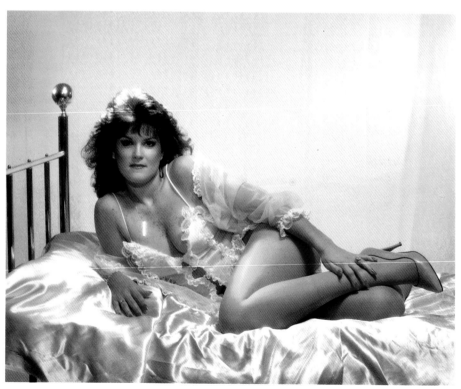

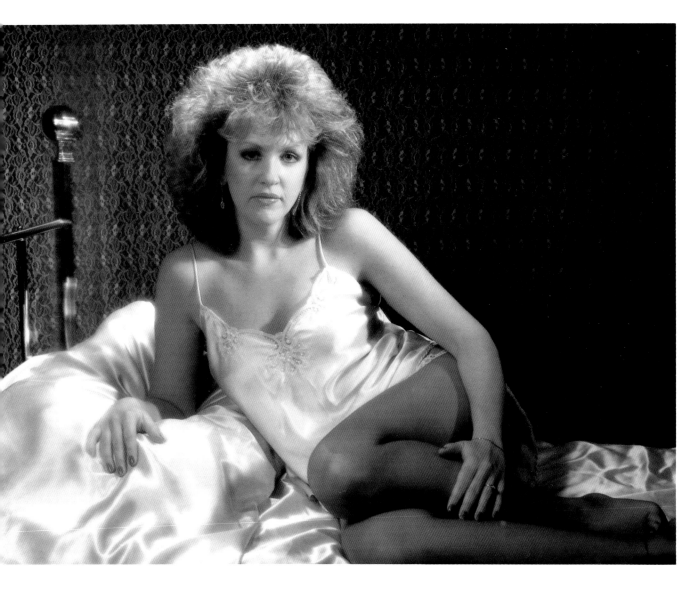

Typically, I select poses for each client according to her body shape. One flattering position for almost every client is to have her recline with one leg over the other, which puts a curve into her hips. Ask your client what special parts of her body she or her husband prefer to accentuate—for instance, her back, legs, breasts, posterior, etc.—and structure each pose accordingly.

Consider the way you position her arms and hands in reference to the total look you are trying to achieve. Always keep the placement of hands and arms delicate and understated. If the client has nicely manicured nails and pretty hands,

contrast them against her skin or the material of her outfit.

After positioning the client, concentrate on eliciting attractive facial expressions from her. Have her move slowly, and since she isn't a professional model, allow her time to adjust. Be patient and constantly reassuring. Have your stylist retouch her, blotting perspiration as the shoot progresses, and encourage her to be totally at ease and to enjoy herself. Tell her that she looks marvelous! that she has beautiful teeth, legs, etc. Be flattering and you'll be sure to get that "look" that sells so many boudoir photographs.

CORRECTIVE POSING TECHNIQUES

The more you can break away from the "norm" when posing clients, the more successful you will become. The "norm" I'm referring to here is that standard head shot, the posing-your-client-staring-off-into-space-with-a-hand-under-the-chin kind of look! You must get away from it, for the simple reason that it is stagnant and no exercise for your creativity, which you need to develop to its fullest potential. Why worry about creativity in a commercial business? Simple—so that when a client requires or demands something different or powerful from you, you can deliver it. Also, so that when you have an idea for a client that might enhance her looks, you can go ahead and do it!

Look at the details involved in your composition, and don't forget that you are photographing the whole body. Pay special attention to how you place the hands, feet, legs, mouth, and every part of your client. Don't shoot a frame if something looks unnatural, for instance if her hand is too large or her foot is twisted. Your client will notice it in the proofs. Take time to position her in a natural pose. Work with your client; be honest and explain why you are giving her certain directions. Above all, cultivate the fun aspects of boudoir. Don't be embarrassed to tell her that the way she is lying makes her leg, arm, bottom or whatever look too big. If you tell her tactfully but firmly what looks good and what doesn't, you'll find that your sales orders will benefit correspondingly. What follows are some strategies involving camera angles, lighting, and positioning different parts of the body, which will help you plan your session.

It is advisable to model your client in a variety of poses, because until she sees proofs of herself, she may be uncertain about what she considers her most attractive features. Moreover, you may privately disagree with her—but remember that she is the customer. It is your job to provide her with a good selection for making her final choice.

Photographic Formulas For Correcting Body Proportions

TO HIGHLIGHT

SUBJECT'S FEATURE	CAMERA	LIGHTING	POSE
ROUND HEAD	low angle	main light low	full face toward camera
NARROW FACE	at eye level	main light high	3/4 profile
PROTRUDING EYES	low angle	flat light from front at eye level	head tilted back, eyes focused on lens
BIG EYES	at eye level	side light	full face toward camera, eyes looking to right or left of lens
SMALL EYES	at eye level	main light at eye level	full face toward camera
LARGE MOUTH	at eye level	main light high	head tilted back, full face toward camera
PROMINENT CHEEKBONES	below eye level	hard, strong light from above	head tilted forward, strong makeup

TO MINIMIZE

ROUND HEAD	at eye level	back light	profile
NARROW FACE	high angle	broad main light at same low height as camera	full face toward camera
PROTRUDING EYES	high angle	position high	full face toward camera
BIG EYES	at eye level	soft, diffused light from both sides	eyes squinted a little, full face toward camera
SMALL EYES	below eye level	position high	head slightly tilted forward, full face toward camera
LARGE MOUTH	at eye level	main light front and slightly above camera	3/4 profile, head forward
ROUND NOSE	at eye level	main light front	profile
NARROW NOSE	low angle	main light below eye level, and directly into face	full face toward camera
FAT CHEEKS	above eye level	soft side light	head tilted back a bit, profile or 3/4 profile
PROMINENT CHEEKBONES	above eye level	eye level	head tilted back, full face toward camera
THIN HAIR	various	no backlight	head straight, no loose strands of hair, hair out of eyes
WRINKLES	diffuse the lens	soft, even front and side light, positioned low	full face toward camera
SCARS	diffuse the lens	shadow area for scar	cover scar with makeup

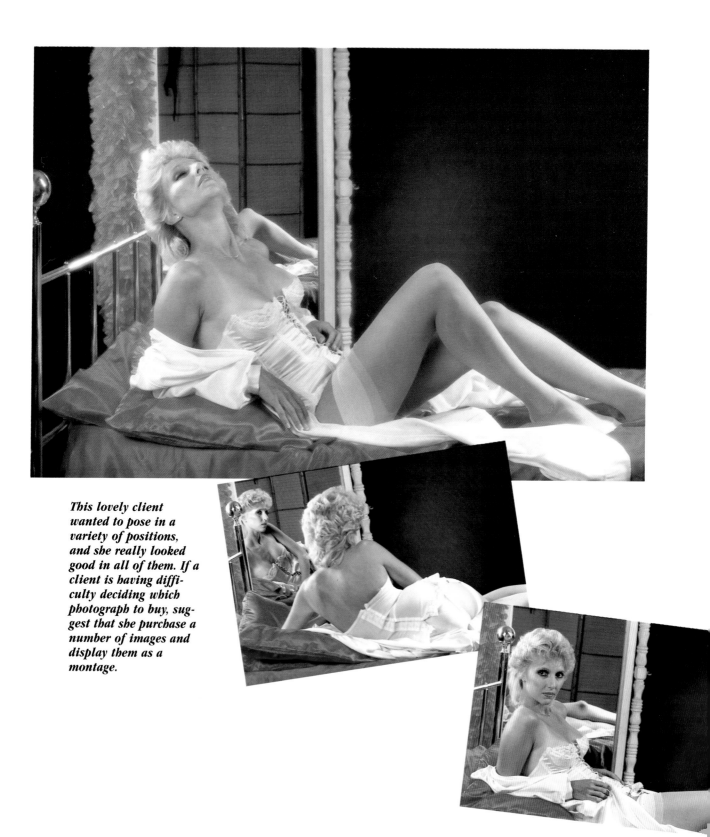

This lovely client wanted to pose in a variety of positions, and she really looked good in all of them. If a client is having difficulty deciding which photograph to buy, suggest that she purchase a number of images and display them as a montage.

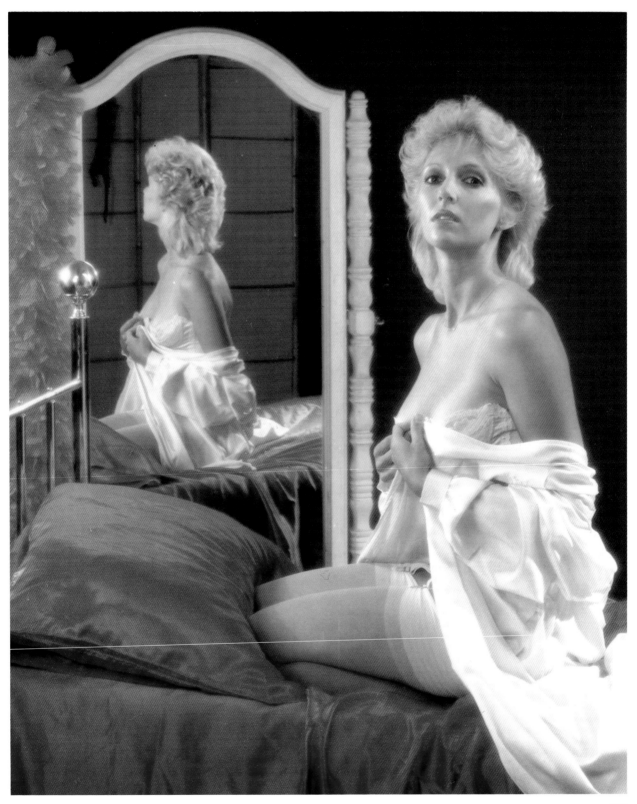

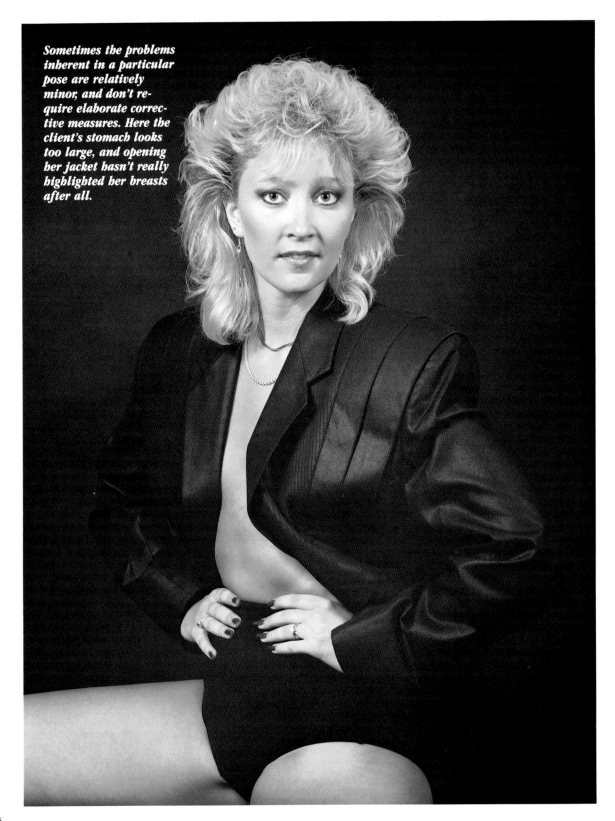

Sometimes the problems inherent in a particular pose are relatively minor, and don't require elaborate corrective measures. Here the client's stomach looks too large, and opening her jacket hasn't really highlighted her breasts after all.

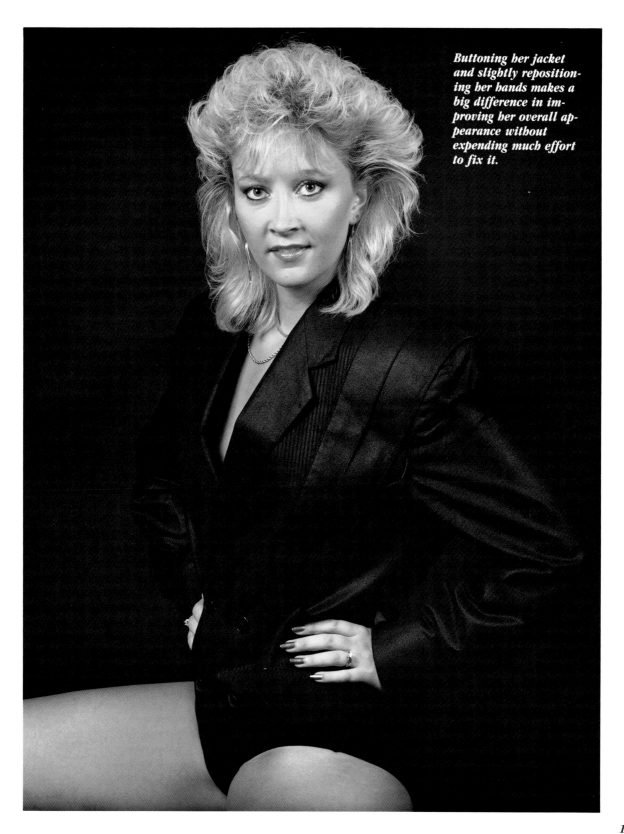

Buttoning her jacket and slightly repositioning her hands makes a big difference in improving her overall appearance without expending much effort to fix it.

Creating the Portrait, Step-by-Step

Michelle Stringini was one of my loveliest clients, and is shown here going through every phase in the process of creating a boudoir portrait. In many ways a typical client, Michelle is single, twenty-two years old, and very intelligent and ambitious. Although somewhat shy, she is daring and open-minded when it comes to new ideas—and as you can see, she has a shining personality!

Like most clients, Michelle seemed a little nervous when she first arrived carring an assortment of lingerie. Later she told us that she had bought some of these outfits just for the shoot.

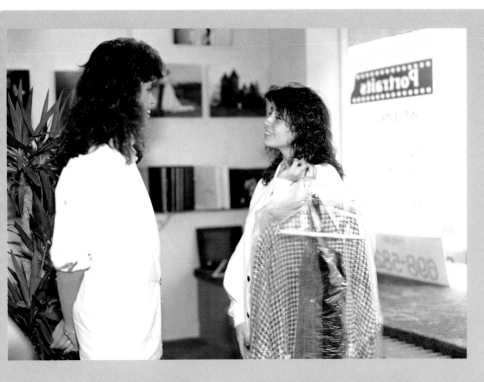

Rosalie, my assistant and stylist, greeted Michelle at the door and immediately began to put her at ease.

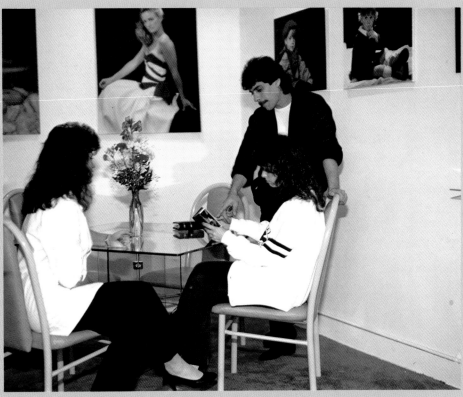

The three of us sat down for a consultation about Michelle's expectations and preferences regarding the way she wanted to look. Here I am showing Michelle samples of my photographs of other clients.

By this time, Rosalie's friendly charm completely overcame any lingering shyness on Michelle's part—the two really hit it off.

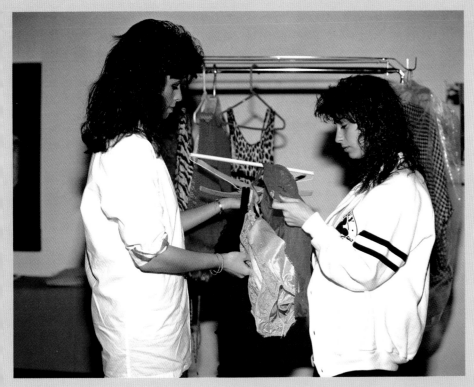

In the dressing room, Michelle showed Rosalie her wardrobe, and Rosalie made suggestions as to which pieces would be the most appealing photographically.

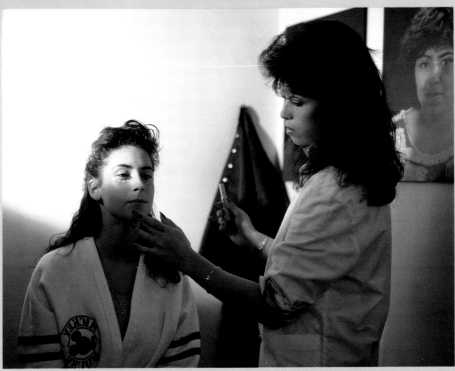

Sitting in front of our big mirror for makeup, Michelle looked on while Rosalie applied dots of highlighter to be blended together beneath Michelle's eyes. By the makeup-and-hairstyling stage, it is important to have won the client's trust in order for everything else to go smoothly.

Rosalie decided to put highlighter on Michelle's chin as well, which helped correct its very slight tendency to recede.

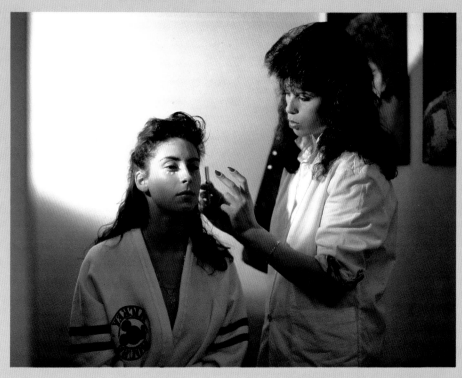

Rosalie brushed powdered blush on Michelle's cheeks, giving her a healthy glow and emphasizing her cheekbones.

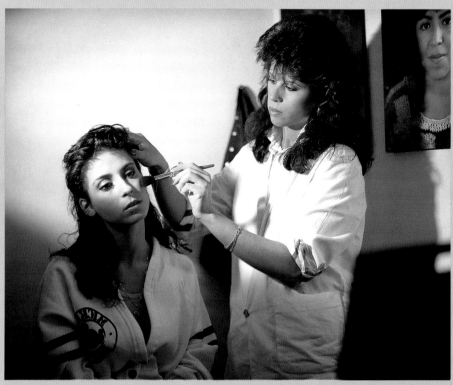

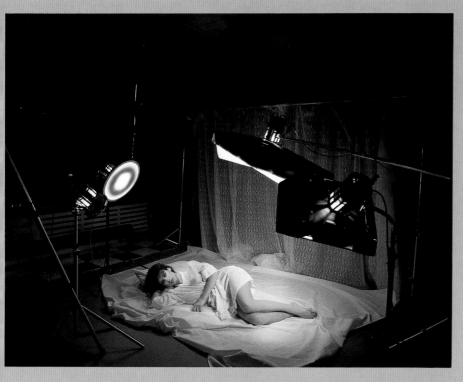

After changing her clothes for the photo session, Michelle struck her first pose on the set. Like many clients, she felt comfortable beginning the shoot with this simple, reclining, leg-over-leg position.

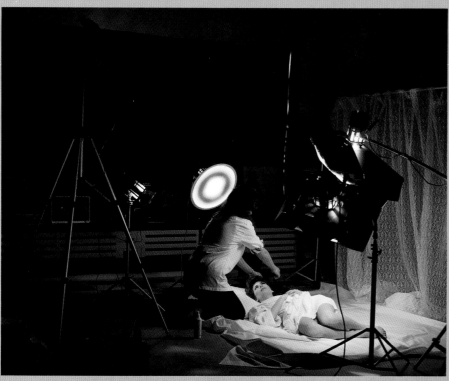

Throughout the shoot, Rosalie was on hand and ready to fix smudged makeup, drape clothing attractively, or rearrange the way Michelle's hair fell across the pillow.

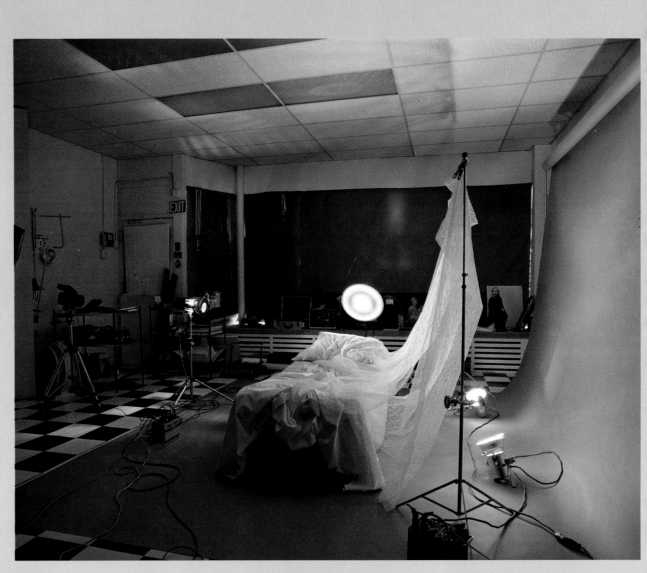

While Rosalie helped
Michelle change into
her second outfit, I
broke down the first set
and installed a real bed
as part of the new set. I
had decided to bring the
camera down to

Michelle's eye level for
the second part of the
shoot, and it was easier
to bring her up to a
normal bedside level
than to shoot with the
camera on the floor.

At the end of the session, Rosalie helped Michelle pack up her clothes. Michelle felt wonderful, and told us she couldn't wait to see the color proofs.

Michelle was delighted with the pearl tones in these photographs. This soft, diffused lighting was achieved by using two Prisma light-boxes in addition to a grid-spot and another light-head.

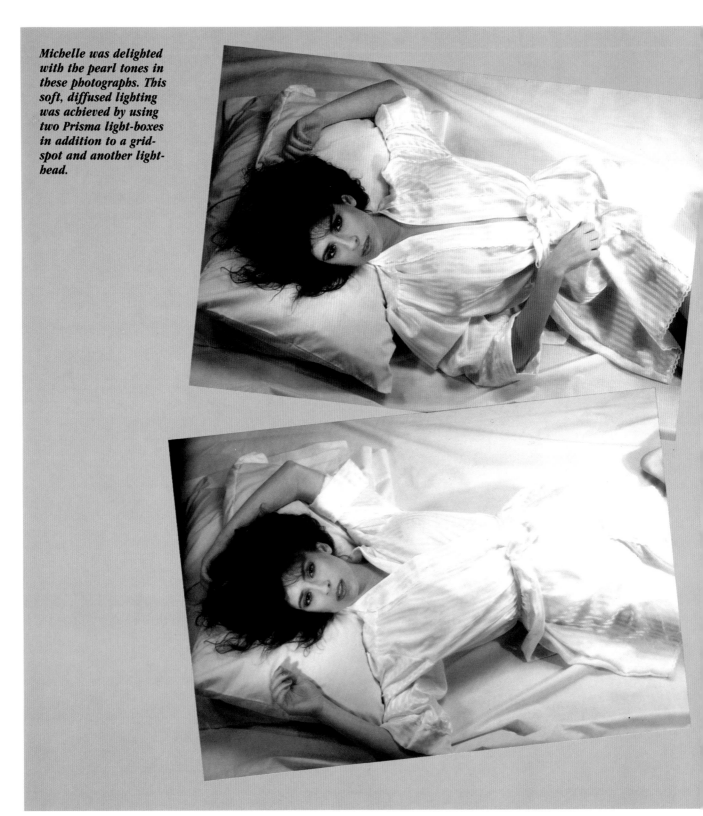

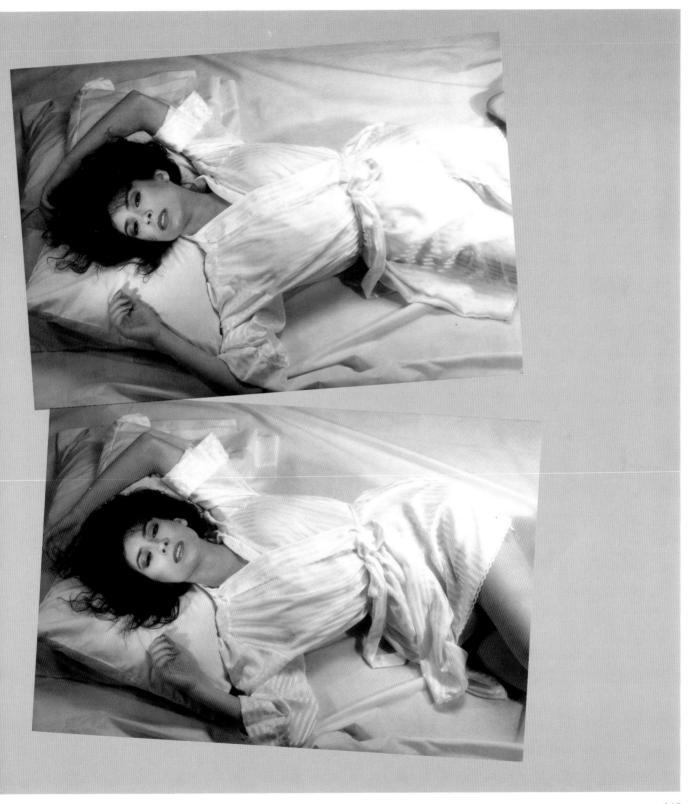

115

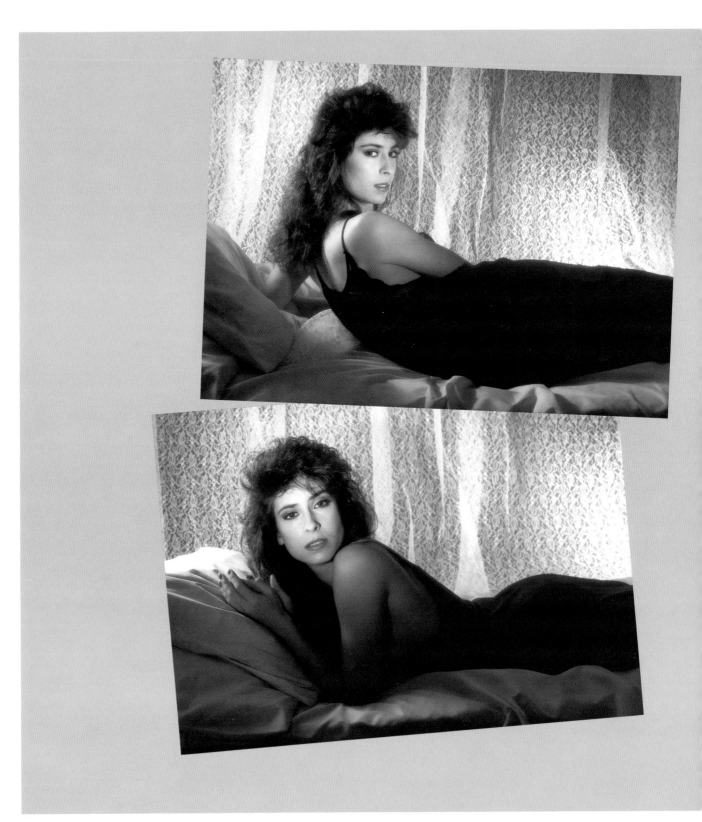

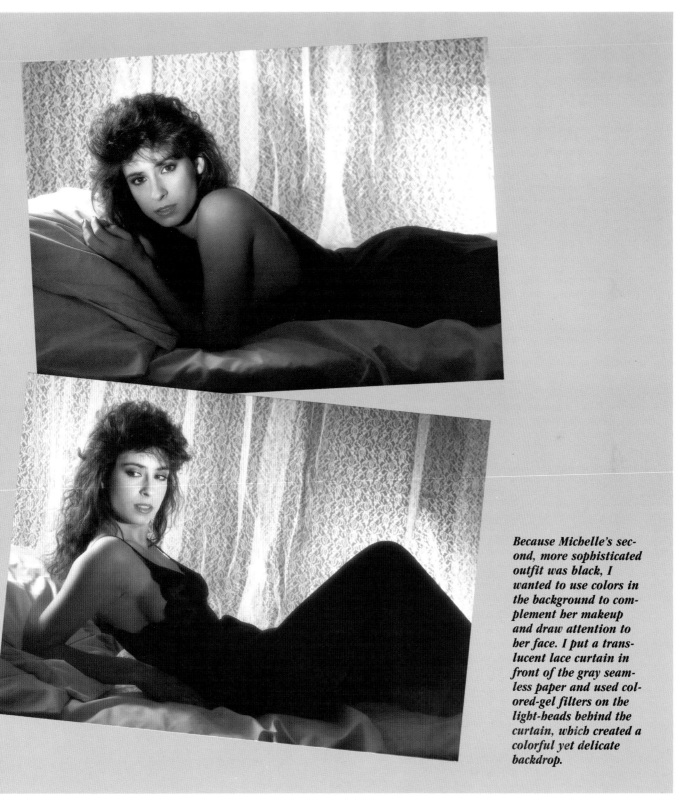

Because Michelle's second, more sophisticated outfit was black, I wanted to use colors in the background to complement her makeup and draw attention to her face. I put a translucent lace curtain in front of the gray seamless paper and used colored-gel filters on the light-heads behind the curtain, which created a colorful yet delicate backdrop.

117

PREPARING FOR THE FINAL SELL

Part of the secret of running a successful studio is to develop good referrals to other businesses. You need vendors that you can rely on for speedy delivery of photographic stock, which is critical for a day-to-day studio operation. Find a camera store in your area that you respect and that can give you discounts on buying bulk quantities of film, accessories (such as spray mount and lacquers), or any other item you might need to complete your portraits.

LAB WORK

If the store has a lab on the premises, establish credit with them, so that you can be put on a billing system that benefits you. Building working partnerships with labs and camera stores will make your studio operation a lot smoother. Being able to find people on whom you can depend for meeting deadlines is just as important as booking daily shootings. Using more than one lab is another possibility. Sometimes you will need to have your photographs custom printed or cropped in a special way that an automated mask can't provide.

Black-and-white portraits will have a faster turnaround time back to your clients than color portraits have. All black-and-white prints should be hand printed to achieve perfect skin tones and consistency with each other. If possible, always use the same lab. Meet the printer who is going to handle your account and discuss how you like your prints—their tonal quality and cropping—with

him. Go over the different degrees of diffusion needed for various sorts of clients, and give him a sample of an ideal black-and-white print to use as a master.

Once proofs have returned back to the studio from the lab, treat them as cautiously as you would treat money! Carefully scrutinize every proof. Formulate a plan for presenting the proofs to your client, and edit them to eliminate any shots where the client's eyes were closed. (Those prints definitely won't sell.) If the proofs are too light or were printed with a lot of dust marks, return the ones that don't measure up to your standards to the lab. Proofs are your client's first impression about the quality of your end product, and are a forecast of the prints she may or may not order. Don't excuse them because they are just proofs— you understand that, but does she? It is very difficult for the client to imagine what her final prints are going to look like if her skin appears to be yellow or cyan in her proofs.

PRESENTING COLOR PROOFS

I normally present at least twenty proofs to a client, but first I always make a point of personally previewing all of them. This enables me to develop personal recommendations and suggestions to give her along with the preliminary sales guideline. It is important to be ready with suggestions, reasons, and honest answers. Show her the proofs in the privacy of the studio's

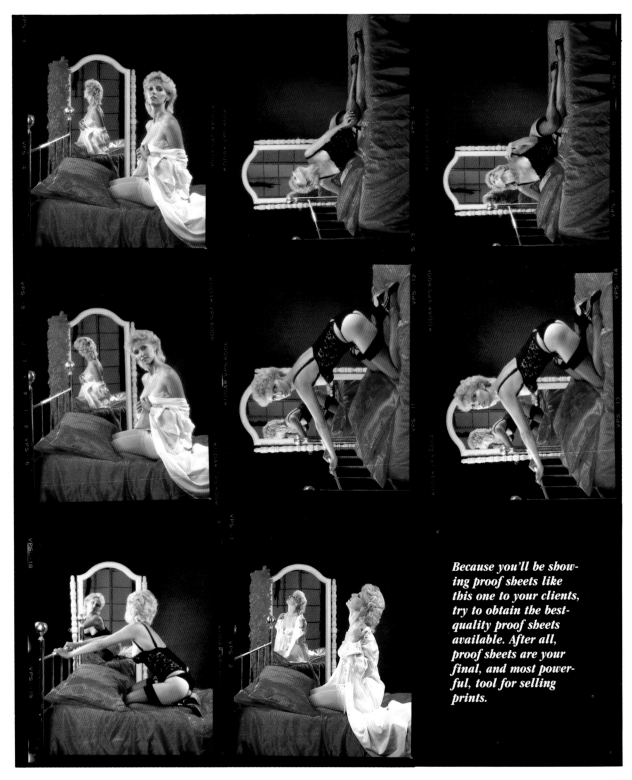

Because you'll be showing proof sheets like this one to your clients, try to obtain the best-quality proof sheets available. After all, proof sheets are your final, and most powerful, tool for selling prints.

In a pocket-sized photo, this client may look sweet—but in a 20″ × 24″ framed print, sweet becomes sultry, and with her autograph in white across the top left corner, this could be a knock-out image and a great gift idea.

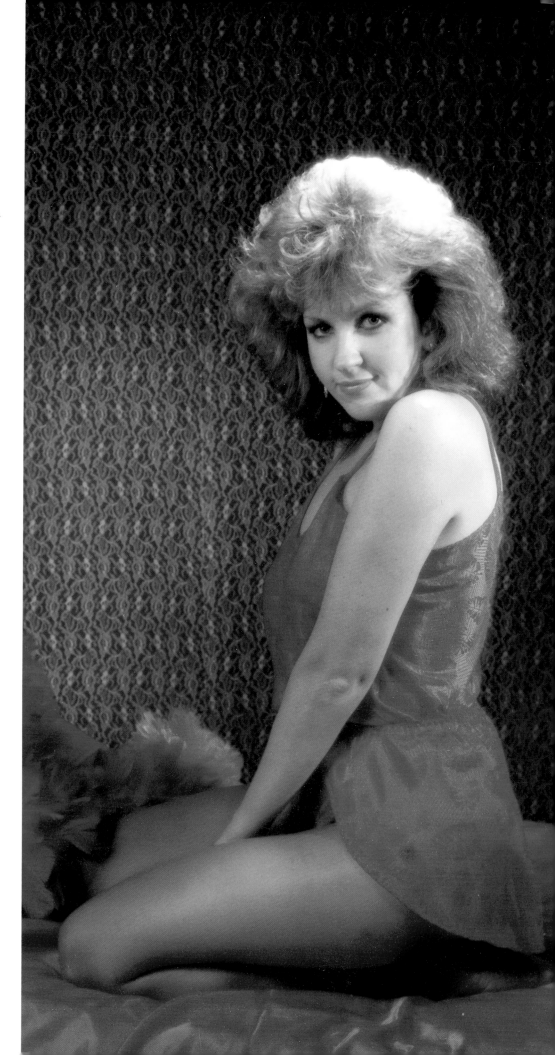

consultation room, in order to eliminate being disturbed by the telephone or walk-in traffic. Be pleasant, and again, be reassuring—offer her a cup of coffee or tea, or a soft drink. One way to present the proofs is by spreading them out in some kind of order. Then use cropping arms to show your client what can be done to improve the final composition of each print. Listen carefully to your client's comments during the presentation. If she likes a photo, you must like it, too. *Sell!*

Explain to her that cosmetic imperfections such as moles, blemishes, scars, and bags under the eyes are easily eliminated from the finished portrait, which you can demonstrate by showing her before-and-after photos of other clients. If her legs or arms look too large, tell her that you will crop them if you can.

Portrait sizes are directly correlated to a financial success in boudoir photography—larger portraits generate a greater profit. To sell large prints, demonstrate their superior impact by comparing them with smaller prints of the same image. The difference between a 20″ × 24″ print and an 8 × 10 is dramatic. Give your client a sales pitch about how she will have this photograph for the rest of her life, how it's much more than just a photograph—it's an image preserved for her to reflect back upon in later years. Don't hang any 5 × 7s or 8 × 10s on your studio walls. If the client is dead set on ordering only one 8 × 10, suggest that she buy some additional accessories, such as an elegant frame, mounting, or other extras that will increase your initial sale to her. If the client orders one 8 × 10 and says she will come back in six months to order more prints when she has more money, another technique to try is offering her a special now that won't be available in six months. Try this tactic at your own discretion, but remember that chances are she won't return to order more anyway.

Once the client has placed an order, the two of you will need to decide whether to finish the photographs with a matte surface or with a glossy surface. Matte will help to hide some flaws, at the expense of blurring the image a bit. Glossing will reveal every detail in the print, and will emphasize its color and vibrancy. Using an "N"-surface paper is best when retouching is required, because of its smooth surface grade.

I only resort to retouching prints when my makeup artist cannot correct the flaws before the shoot. Then I spray the final print with a special retouching lacquer, and use Berol Prismacolor pencils to fix the problem area. How much to charge for retouching should depend upon the amount of time involved, the size of the portrait, and how extensive the problem is. At my studio, this usually adds up to charging an additional thirty to fifty dollars an hour for this extra service.

An alternative to showing your proofs as prints is showing them in a slide-show format, which has some side benefits: the bigger-than-life-size images can be more powerful than standard photographic prints, and because the slides won't be removed from your studio, the client is forced to order prints on impulse right then and there. How you decide to display your proofs depends partly on your studio's layout and partly on the type of client you serve. If showing slides brings you bigger orders, use them; otherwise, stick with printed proofs. I like using the printed variety because they allow me to crop for the final image right in front of my clients, and to make marks on the proof itself, thereby showing the client exactly what will appear in the finished photograph.

MONEY MATTERS

Sell what you can at the time of the presentation, without pushing too hard, of course. There is, however, a point about which you or your salesperson should never compromise—your money. Upon getting an order for prints, insist on being paid up-front for half the amount owed, and have every client sign a contract. Past experience has taught me never to start an order until I have at least half its price on-hand.

I only let proofs leave my studio when the client in turn leaves a deposit with me. This deposit is refunded to her when she returns the proofs, which is also my insurance that she will come back to place an order. Of course, her money can be refunded even if she decides not to order anything, but having to come back anyway is usually good incentive to go ahead and order something. Meanwhile, the studio benefits from having access to the money held on deposit.

121

How you price your prints depends very much on your clientele and the area in which you choose to operate. Remember that higher-priced, middle-class neighborhoods are going to demand a higher rent for your studio space, which doesn't always translate into better income simply because there are nice homes in the area.

I've found that one of my best business techniques is to remove myself from any discussions or inquiries regarding final pricing. This is accomplished by having one of my employees oversee all these final details, do the paperwork involved, and collect the fees.

Always copyright your prints to discourage people from going to local camera stores to have reprints made. Your copyright stamp will be respected by honest stores, which will force your clients to return to your studio for additional copies.

When my clients come to pick up their final prints, as an added feature I always include a guarantee from the color lab covering any deterioration or fading in the photographs. I also enclose a set of portrait-protection instructions that describe how to care for the photographs. This final touch helps to reassure and satisfy clients about the quality of the product they have paid for—and I depend on the referrals that satisfied customers make!

Clients who go home with beautiful portraits to show their friends and lovers are my best salespeople. That's why I always do my best to satisfy my customers.

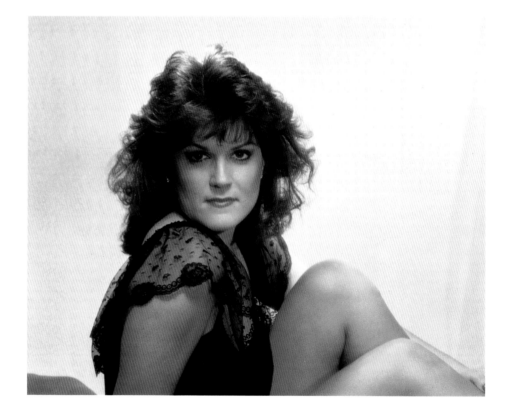

Dear Mario,

Having boudoir photographs taken of me has always been a fantasy of mine. When I moved to Chicago four years ago, my boyfriend was an avid, girlie-magazine reader—or should I say gazer—to the point of obsession. I decided to see about having some photos of myself taken so that he could gaze at me! I had seen this type of photography advertised on television, and wondered how to go about having it done.

One afternoon in my doctor's office, I was reading *People Magazine* and I saw an article about you and how you worked here in Chicago. I looked up your studio's number. I was a little nervous at first, but I called anyway and talked to Rosalie, asking her numerous questions, such as what to wear, should I bring my own clothes, what was the cost, etc.

I made my appointment for a couple of weeks later. When I first arrived at the studio I was very nervous, but as I went to have my hair and makeup done, my inhibitions gradually disappeared. Rosalie made me feel very comfortable and at ease. After I saw the fabulous job she did on my hair and makeup, I knew this wasn't going to be the unpleasant experience I had anticipated. And you were great at getting me to relax, and gently guiding me on how to turn, smile, and tilt my head.

After it was over, I couldn't wait for the call from your receptionist telling me that the proofs were back from the lab. I went in as soon as I got word, holding my breath until I saw the first proofs. They were marvelous—I was so excited. I couldn't believe that untouched proofs could be that good. In fact, my biggest problem was deciding which one I liked the best. In the end, I couldn't decide between two pictures, so I got them both. The pictures are just beautiful; everyone thinks they are painted portraits. They are something I'll have forever, and I thank you and Rosalie for doing such a wonderful job and making it such a fun experience.

Sincerely yours,

Doreen

Doreen

THE FANTASY FULFILLED

The recurrent theme in all the boudoir work that you do with your clients should be *fun*—and you along with your associates and staff are responsible for emphasizing that. You are selling your clients an opportunity to have, if you will, a brief encounter with that carefree, sensual, tantalyzing part of themselves that they aren't sure even exists.

Each client comes to you for unique reasons, and is depending on your professional expertise to document something special about her life. The technical ability that you have at your disposal will be your basis for doing a quality portrait. Given that foundation, I suggest that you treat every client's session with an imaginative singularity of purpose, making every effort to be creative by searching out details that can be emphasized in each portrait. Above all, continue to experiment, and improve and embellish your own signature style by keeping abreast of changes and new developments in the photographic industry.

Encourage your makeup-and-hair stylist to pay attention to current styles and to apply them when working with your clients. Fashions are always changing, and you should be ready to adapt your approach to the new styles and trends that develop. This applies as well to filtering new ideas throughout your entire business. Always keep your displays fresh—it's not a good idea for your clients to see a stagnant environment when they visit your studio.

In order to prosper, you should strive to produce portraits of consistently high quality for every client. Always endeavor to enhance and improve your products, thereby reaping the financial as well as creative and emotional rewards of doing boudoir photography. Moreover, the gratification that comes from knowing how much your work pleases your clients is well worth whatever effort you put into your business.

Throughout this book you've had an opportunity to read some of my client's own descriptions of how they overcame their apprehensions and anxiety about posing for boudoir photographs, along with their innermost thoughts prior to, during, and after completing the boudoir portrait. Their desire to see themselves portrayed as sensual, glamorous women won out over their fears of what people think—especially after their husbands or boyfriends saw the photographs. I would like to leave you with a few of the husbands' equally important responses to boudoir photography. Good luck, and remember—enjoy yourself.

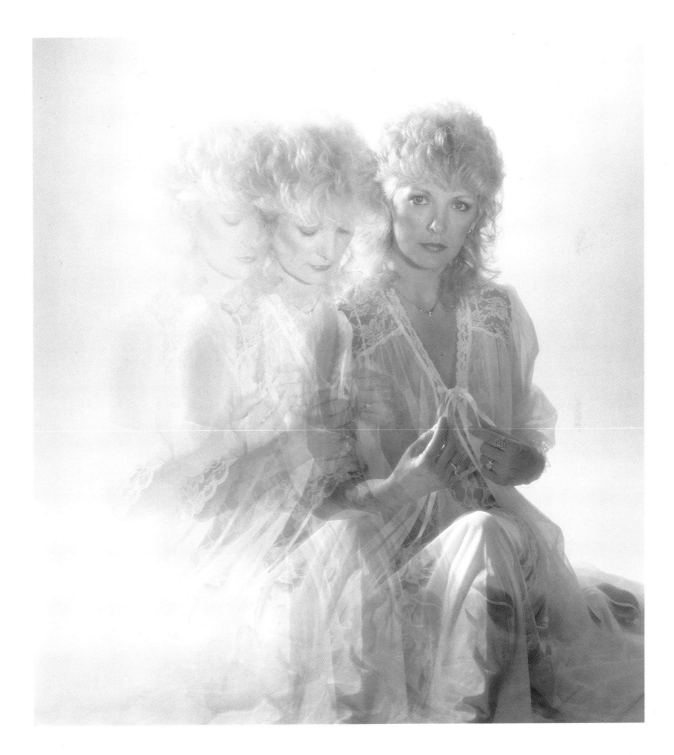

Dear Mario,

When my wife Adeline got the idea of posing for this kind of photo-graph, I have to admit I was a little uncertain about it—after all, Adeline is forty-nine years old. But she insisted on going through with it. We had heard of Mario Venticinque from *ABC Channel 7 Eyewitness News* in Chicago, and we realized he was a professional photographer, not just someone moonlighting with a camera. My wife phoned his studio to make an appointment. On the day prior to the shooting, Adeline asked me what I would like her to wear and to look like. I said Raquel Welch. Well, Mario wasn't able to fill that bill, but he did make a gorgeous portrait of Adeline at her best.

The whole idea behind the entire process was for it to be a lot of fun. After twenty-six years of marriage, it's nice to finally have a beautiful portrait of my wife at home. My hat's off to you, Mario.

Harry

Best Wishes
Harry

Dear Mario,

This year for my birthday I received a gift that was really special: a boudoir portrait of my wife. For several weeks prior to my birthday, I thought she was acting very secretive, almost sneaky, and she teased me a lot about what she was going to get me. When I questioned her about it, all she would say was, "You'll see, you'll see"—and boy, oh boy, did I ever when I opened up my present! I almost didn't believe my eyes; in fact, it was hard to believe that it was Carol. We have been married for almost five years now, and we've known each other for about six years. I'll tell you, she never looked that good before. I was really pleased with the photograph. I don't know that much about photography, but it seemed to have been done very tastefully and professionally. I think it gave Carol a kind of ego boost as well, especially when she saw how happy I was with it. Every husband should be lucky enough to get a birthday present that great.

Thanks,

Jack

Jack

INDEX

Editorial concept by Marisa Bulzone
Edited by Robin Simmen
Designed by Damien Alexander
Graphic production by Ellen Greene